IMAGES
of America

BUILDING
SAVANNAH

IMAGES
of America

BUILDING
SAVANNAH

David E. Kelley

ARCADIA
PUBLISHING

Published by Arcadia Publishing
Charleston, South Carolina

Printed in the United States of America

Library of Congress Catalog Card Number: Applied for

For all general information contact Arcadia Publishing at:
Telephone 843-853-2070
Fax 843-853-0044
E-Mail sales@arcadiapublishing.com
For customer service and orders:
Toll-Free 1-888-313-2665

Visit us on the Internet at www.arcadiapublishing.com

CONTENTS

ACKNOWLEDGMENTS

The intention of this book is to provide a visual survey in aspects of the building industry in Savannah during its peak. I hope to capture a brief glimpse of the area's unrecorded history through the evidence of primary source photographs and documents. Limitations of space and visual material make this study only a step in the process of investigating the construction of the city. I do not intend for this to be a book on architecture, but architects play a significant role in the process. I have tried to exclude any pictures and material that have been previously published (i.e. no squares, no colonial plan, etc.). Flush with architects, builders, and artisans, the construction industry, from its beginnings in the 18th century, developed with fortitude and grace through the wood, brick, and iron of the magnificent edifices of our Forest City. I hope to tell part of that story. The research that went into this book will, for the use of further investigation, be in the collections of the Georgia Historical Society, which contains a unabridged bibliography of sources and a Savannah building trades database. All images courtesy of the Georgia Historical Society (GHS #collection) are abbreviated and labeled by collection number for quick reference, and the book contains a complete index on page 128.

I stand in appreciation of those diligent historians, architects, and amateurs who had the foresight and respect to study, love, and preserve the history of Savannah's built environment. I would first like to thank Bob Dickensheets for the catalyst and encouragement for this project. Thanks go to my teacher and friend, L.G. Wilson, for the patience, diligence, and education that so many have received; to Ramsey, Pam, Laura, and the crew at Savannah Lumber for believing in this town on a level that many do not understand; to John Duncan, for his erudite and gracious expertise while allowing me in his home to search his collections; to the Honorable Mr. and Mrs. Hermann W. Coolidge, for the use of their extensive library; to the irreplaceable staff of the Georgia Historical Society—Mary Beth, Mandy, Jessica, Kim, Susan, and Coby (who, all respectable researchers know, <u>love</u> chocolate)—for their knowledge, understanding, and help; and finally, and finally to my family, for their love, criticism, support, and humor, without which this could not have been possible.

And of course, thanks go to the Bolton Street Inn, its illustrious proprietor, and its decadent inhabitants, to whom I owe the thanks and pleasure of several years as its caretaker.

INTRODUCTION

The architecture of Savannah has been recorded and studied by many 20th-century scholars for the quality and dynamic nature of the its built environment within the colonial plan. The period from 1850 to 1900 in Savannah was the time of the city's most prolific expansion and development. Despite the disasters of the Civil War, Savannah was spared the wrath of Union forces and emerged from the 1860s psychologically defeated but significantly physically intact. The Civil War and subsequent quagmire of reconstruction ultimately could not retard the economic and technological changes that were already transforming the South from a mostly colonial-agricultural to a more industrial-agricultural civilization.

The significance of this period for Savannah is seen in the visual documentation of the city. Early exploration and utilization of the area's natural resources had contributed the finances needed to encourage growth. Building had begun, and eventually the city's industry embraced the combination of architectural ideas and industrial transformations that were affecting the entire country during the later half of the 19th century. This process would grow on a fundamental level by the democratization of ornament and design. Architects, builders, and patrons developed new relationships that used the fruits of the pattern books and social ideals to meet the construction of a semi-urban setting. Thousands of buildings were erected in Savannah during the time between the Civil War and the turn of the 20th century, and the business of building flourished. The building trades of carpentry, masonry, plastering, and painting experienced tremendous opportunities in the booming environment. To accommodate for the new construction, lumber mills, planning mills, iron foundries, brick factories, importers, and exporters expanded and thrived through technical innovation and mass production. "Savannah is beyond question a building city," reported the *Savannah Morning News* in the fall of 1888. Eventually, the successful technology transforming the cotton, lumber, ship, and construction industries would exceedingly drain the resources of the South.

The final expression of the period was that left in the homes and businesses of its citizens. By the Second World War in Savannah, many of the city's greatest architects, builders, and businesses had faded, and the era ran its course. The Georgia pine harvest was over, and most of the local mills withered. New metals would limit the possibilities of old foundries. The mass production of building materials that had begun with the construction of early America would, through consolidation and economics, discard the older skill and practices of the industry. The ornate architectural trends that were once so new to the city changed like they always had before. In Savannah and a majority of American cities, what had been the "suburbs" for the streetcar would become the "city" for the automobile. The art of building in Savannah has learned, from this process, to respect the value of workmanship in our built environment

And for these boys and men whom shall forever chase

the beauty of women into the arms of stone, steel, and glass,

may their blessed souls rest in fresh pine boxes where the last great trees grow

—Anonymous

One

FOUNDATION AND RESOURCE

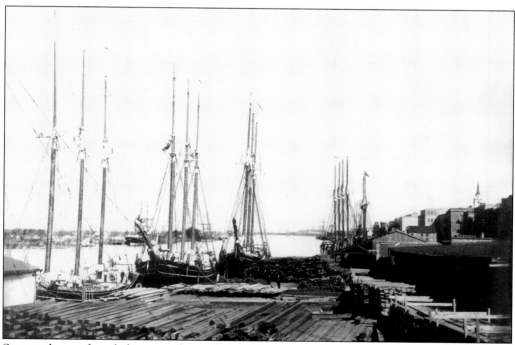

Savannah was founded on an elevated bluff above a gentle river. River and resource have, with time, combined in response to define the people, places, and potential of the city. Many with families, and others alone, the inhabitants came from distant shores hoping to start businesses and build homes. Their determination, skill, and ingenuity would transform the original town of wooden shacks into a bustling port city equal to any in the Union. (GHS Cordray-Foltz #1360PH.)

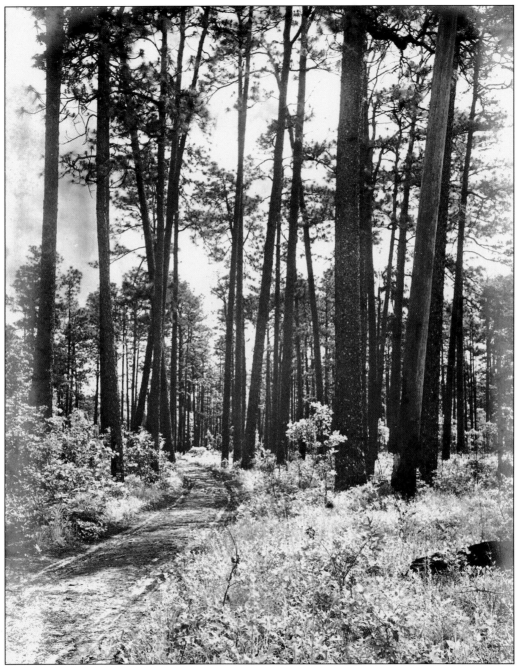

The mythology surrounding the original virgin forests of the Southeastern United States is obscured by the scrub oak, stumps, and pulpwood trees that now dominate the land that was once covered with magnificent expanses of longleaf pine, live oak, and bald cypress. The vast forests represented mere obstacles in the way of agriculture for the earliest settlers. Described by many visitors as containing an "inexhaustible supply of timber," the forests would remain largely untouched until the end of the Civil War. (GHS #VM2126.)

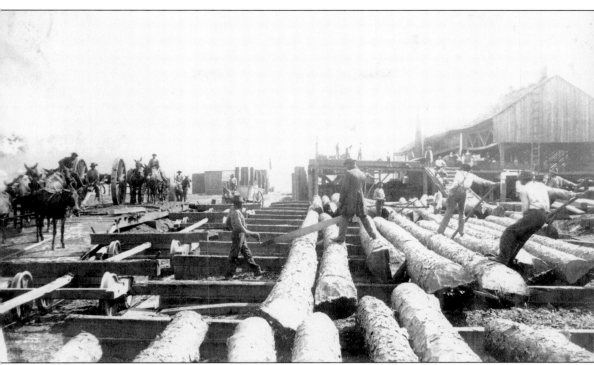

The sawmill has always established a hub for materials and industry. In 1836, James Hall observed, "ours [may] be called a wooden country; not merely from the extent of its forest but because in common use wood has been substituted for a number of most necessary and common articles—such as stone, iron and even leather." Before the Civil War, African slaves would have completed almost all of the physical labor, making materials for the building industry of Savannah. This image, taken by J.N. Wilson outside of Savannah after the war, shows that even with steam sawmills, much of the labor remained manually performed by freed African Americans. (GHS, J.N. Wilson VM #1375.)

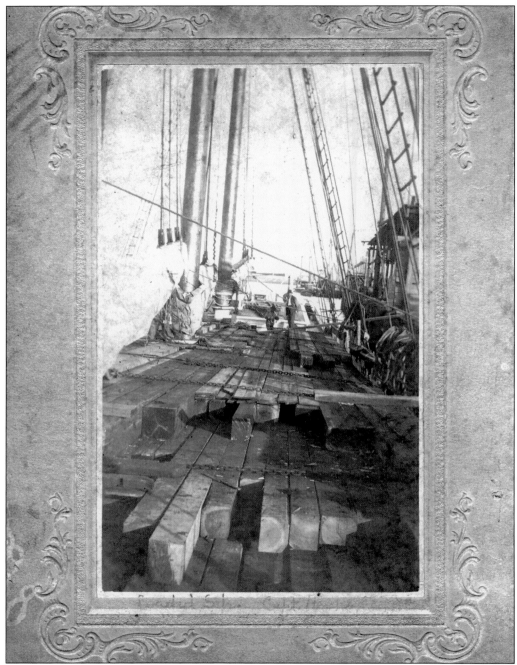

Lumber has been shipped from the Georgia coast since the time of James E. Oglethorpe and the colonists. During the 18th century, the British crown reserved the largest timbers for ship masts and made their unapproved removal illegal under harsh penalty of law. To encourage the clearing of land for agriculture after the revolution, the Georgia State Legislature appropriated 500-acre land grants to reward settlers for the construction of sawmills. Sailing ships would attach timbers for export directly to the deck as seen in this photo, c. 1870. (GHS #1361PH.)

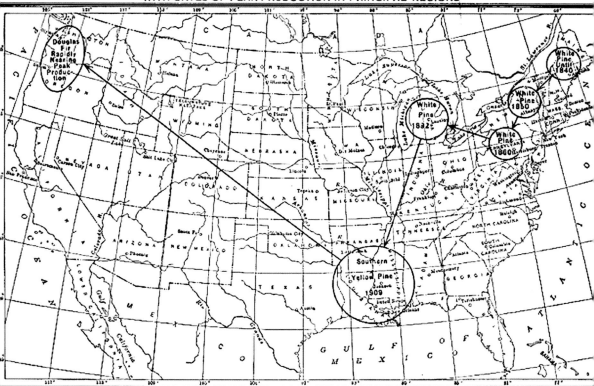

In 1890, the forest resources of America were studied by Charles S. Sargent, and he estimated "there was 333 billion cu. Ft. of timber in South as compared to only 84 billion in the Lake States." Instead of being a cry for the conservation of Southern forests, the work inadvertently became the inspiration of lumber speculators and timber factors throughout the South. Many dubious companies purchased valuable timberlands at a fraction of their value and sold them at an inflated rated once sawmills had been established in the area. (From *American Lumber Industry*, 1928.)

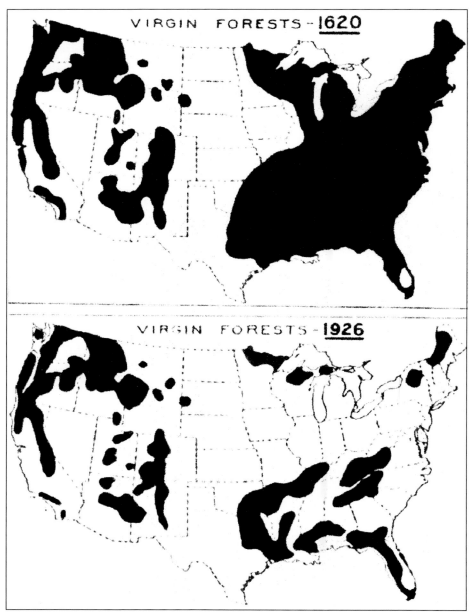

VIRGIN FORESTS - 1620

VIRGIN FORESTS - 1926

The Homestead Act of 1866 limited land purchases to 80 acres and was intended to help establish the masses of disenfranchised ex-slaves, laborers, and refugees while rejecting petitions of confederacy. Northern politicians hoped to use land policy as an instrument to help dismantle the antebellum aristocracy. Despite the intentions of the policy, by 1876 the restrictions were repealed, and the vast acres of timber were open to large-scale purchase. The millions of federal lands released in 1876 became the gold rush of the Georgia pine harvest. (Courtesy U.S. Forest Service.)

14

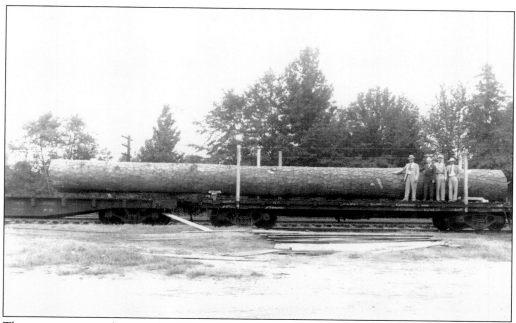

These rare images taken in Florence, South Carolina, c. 1942, testify to the significant physical characteristics of the virgin longleaf pine forests. This log, measuring an average 42-inch diameter and extending nearly 60 feet before branching, was typical in size for the species. The superior designation of "heart pine" refers specifically to lumber milled from the dark inner circle, seen clearly on the end cut of the timber. While still highly valued and sought after, the "heart pine" wood forms only from decades of uninterrupted growth. (GHS #1361PH.)

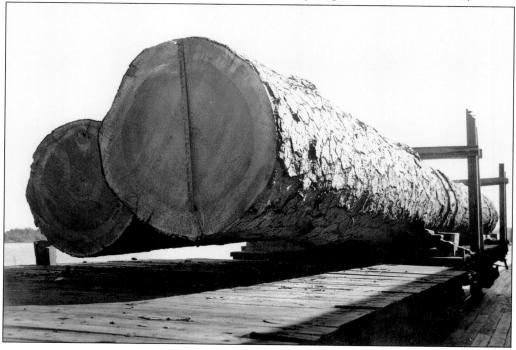

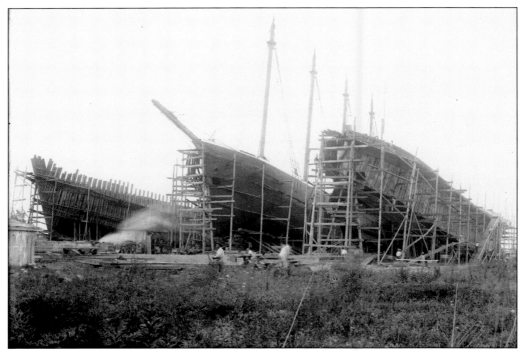

The shipbuilding industry has, on multiple levels, enabled and financed the growth of the city. Beginning with wood and later with iron and steel, the trade would employ hundreds of skilled artisans working in symphony to construct the enormous vessels. (GHS, Edward Girard #1374.)

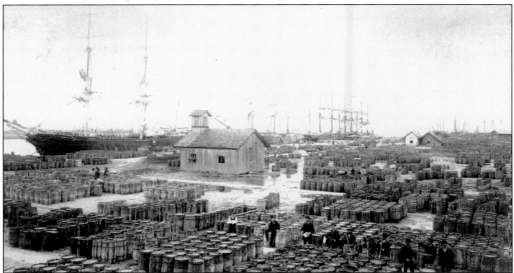

Savannah became the world's leader of shipping naval stores by the end of the 19th century. Wasteful extraction of resins from pine resulted in stunted or malformed growth and often led to the tree's death. Lumbering proponents remained critical of the industry until the turn of the 20th century. In 1901, a little known University of Georgia chemist, Charles H. Herty, would conduct experiments in Statesboro derived from French "cupping" techniques. Herty's conservation work would transform the industry. (GHS #1361PH.)

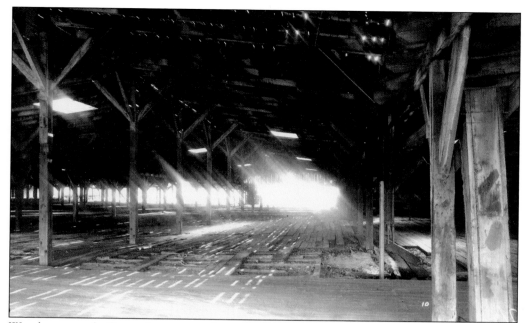

Warehouses to facilitate the storage of cotton, rice, lumber, and naval stores were built on both the east and west sides of town and on Hutchinson Island. The railroads would complete the link between land and sea transportation. This view of the Seaboard Air Line Railway terminal (c. 1930) shows the massive size of these structures. (GHS Cordray-Foltz #1360.)

The storage of flammable materials made fire a constant threat. Despite the use of firewalls to separate these Atlantic Coast Line warehouse, the fire of 1919 consumed the entire area, even becoming hot enough to bend the railroad tracts. (GHS Cordray-Foltz #1360.)

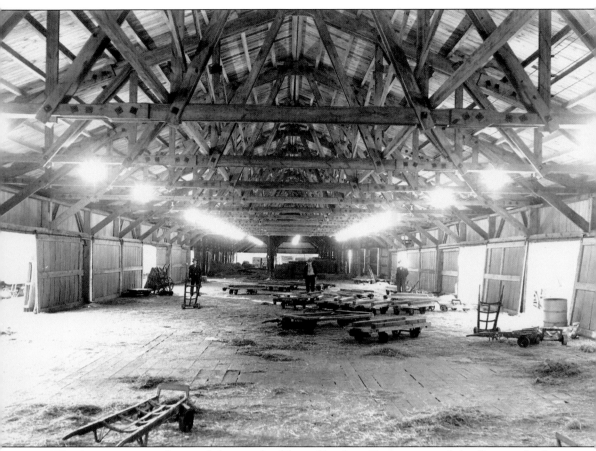

Warehouse construction used thousands of feet of lumber. Owners wanted the floors to be free of obstructions and support columns that would take up space and inhibit movement. This led to the engineering of truss systems to span the full width of a building's interior. This warehouse, dating from the 1880s, is seen here c. 1946. (GHS Cordray-Foltz #1360.)

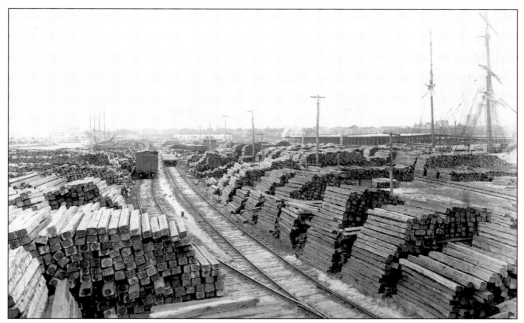

This scene in the yard is filled with timber for railroad ties. The expansion of the railroad in Georgia would facilitate the state's ability to extract resources from the hinterlands of the interior. Railroads made feasible the movement of cotton, lumber, and naval stores from landlocked regions to the coast for export. (GHS Cordray-Foltz #1360.)

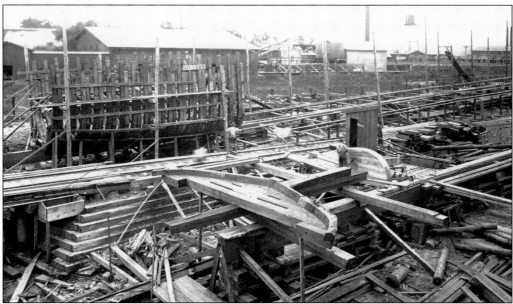

By 1614, shipbuilding had begun in New England and slowly spread down the East Coast. The techniques remained largely unchanged until the 19th century and the new use of steam engines. While bending straight wood was commonly practiced, the natural shapes of live oak were popular materials for the large ribs of a vessel's hull. These shipbuilders are seen here in Southland Yard in 1918. (GHS Cordray-Foltz #1360.)

Richard M Stiles Esqr
for Lot № 15. St Gall.

Febry 3. 1812 } To Isaiah Davenport Dr
13 ℔ of 21ᵈ Cut Nail for his Plantation @ 10, 1 3
12 ℔ do of 6ᵈ do " do , 1 2
46. ℔ of Nails for her House in Savannah @ 10 ,, 4 6
2 pair of Large Hinge for gate @ 8¼ ,, 1 6
one Hinge . . " 2
To New silling a House ,, 17 8
To Weather boardin & Making Steps 10 2
To putting up Rough fence .. . 12 0
To degging a Vault & building a Privy ,, . 10 5
 Recd Payment in full $59 1
 Isa Davenport

The earliest records for building in Savannah are limited, consisting mainly of gentlemen's agreements between artisans and patrons for materials and work to be done. This receipt recorded work done in 1812 by carpenter Isaiah Davenport for Richard M. Stiles on a house on Lot 15 Gallie Ward (?). A native of Rhode Island, Davenport had been in Savannah for only five years at the time of this job and already employed four slaves. Note the diversity of jobs on this receipt that the early-19th-century carpenter would perform. (GHS #846.)

One of the most significant contribution to the early building industry in Savannah came from Henry McAlpin and the Hermitage Plantation, as advertised here in 1821. As early as 1818, the grounds contained significant brick works, a sawmill, and an iron foundry. After the devastating fire of 1820, young architect William Jay advocated the construction of complete iron structures in Savannah, which he dubiously deemed "fire-proof." While McAlpin and Jay would collaborate on many early Savannah mansions, it is not known if either of the builders met the young James Bogardus, who worked as an engraver in Savannah in 1822 and 1823.

The Hermitage gained recognition for the production of a large soft brick, appropriately referred to as a "Savannah Grey." During the fall of 1855, John Scudder, a master builder, purchased thousands of the bricks from the McAlpin Brothers. This bill shows that the Savannah Grey fetched significantly more than a smaller "Hard Brown Brick." By the 1880s, local manufacturers would produce over eight million bricks per year for use in the city. (GHS Scudder Family papers #719.)

Wealth encouraged elaborate forms of architectural display for Savannah's finest homes. In 1840, Augustus P. Wetter attached this elaborate cast-iron balcony to his newly constructed home. Originally designed for the new state capitol at Millidgeville and cast by Wood and Perot of Philadelphia, the work was reportedly rejected due to the $100,000 price. Each medallion contains profile portraits of significant poets, artists, and statesmen. Patrick Henry is immortalized in this image taken in the 1930s. (GHS Cordray-Foltz #1360.)

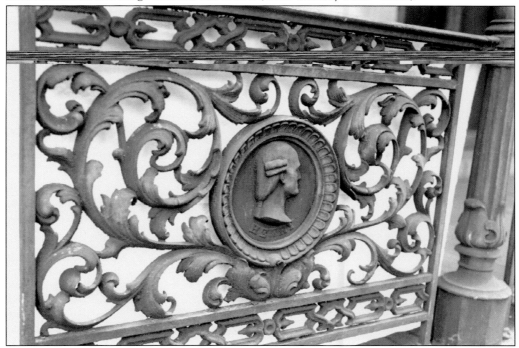

1853 **Hiram Roberts** Dr

To Contract building a double tenement
Brick building for mrs Michel Dillon
April 23 on Joachim Street. Yamacraw for $2400

June 10 To 3/4 day 7 hands $7 ¾ to 11th To 1 day 6 hands $9 ²⁵ 16 50

" 13 To 1 day 7 hands $10 ⁷⁵ 14th 1 day 6 hands $9 ⁷⁵ 20 50

" 15 To 2 days 6 hands $19 ⁵⁰ = To 1 day 3 hands $3 87 23 37

" 18 To 1 day 3 hands $3 87 To two Iron Arch Supporters $2 ⁰⁰ 5 87

" 20 To 1 day 2 hands To 1 day 2 hands $3 ⁵⁰

" 25 To 3/4 day Painting $1 ⁶⁸ July 2nd To 2 1/2 days 2 hands 1 11 2

July 16 To — days hands 27 7

" 30 To days work hands to date 26 9

Finished

H Roberts,

Per Contract Building six Brick Tenements on
Walnut Street, and furnish all Materials $5100 0

Joseph Bancroft's census of 1848 lists over 600 persons, white and black, engaged in businesses and industries related to construction. According to the census numbers, Savannah's population at the time supported 14 master builders, 18 painters, 4 brickyards, and 2 foundries. During the years from 1853 to 1854, this anonymous carpenter/ builder recorded the accounts of his work including this "double tenement brick building for Mrs. Michael Dillon." (GHS #932.)

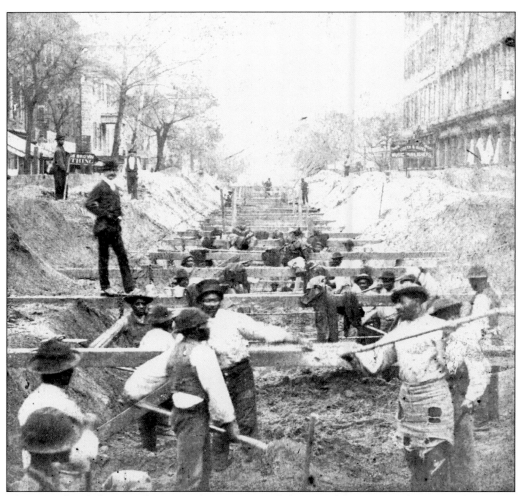

The growth of the population and expansion of the city limits created increased pressure for public works. Local slaves were required by the city government "for a mandatory twenty days a year" of labor on the construction of streets, sewers, or fortifications. Like most American cities, epidemics would kill thousands in Savannah before modern sanitation and medical practices limited the spread of disease. Quarantine was the dominant method of prevention in the 19th century, until a contemporary understanding of pathogens and germ theory was developed. This detail of a stereograph (c. 1880) taken during sewer construction on Broughton Street (?), testifies to the energy invested in these early projects. (GHS #1361SG.)

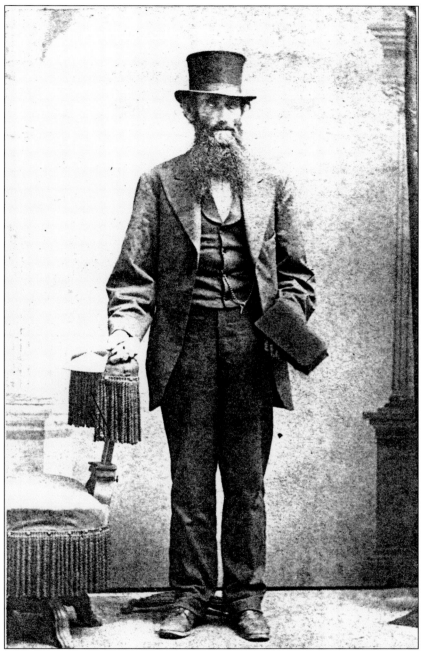

A young Benjamin Remington Armstrong (c. 1822–1901) arrived by ship to Savannah from his home in Jamestown, Rhode Island. Armstrong quickly gained employment in the city working on Fort Pulaski, Fort Jackson, and the U.S. Customs House. A master mason, Armstrong would supervise and contract work for the Central of Georgia Railroad and the Telfair Hospital for Women. This photograph, taken c. 1870, shows Armstrong in his Sunday best with trowel and brick in hand. Note the armrest due to the extended expose time of this early image. (GHS Armstrong Family Papers #VM25.)

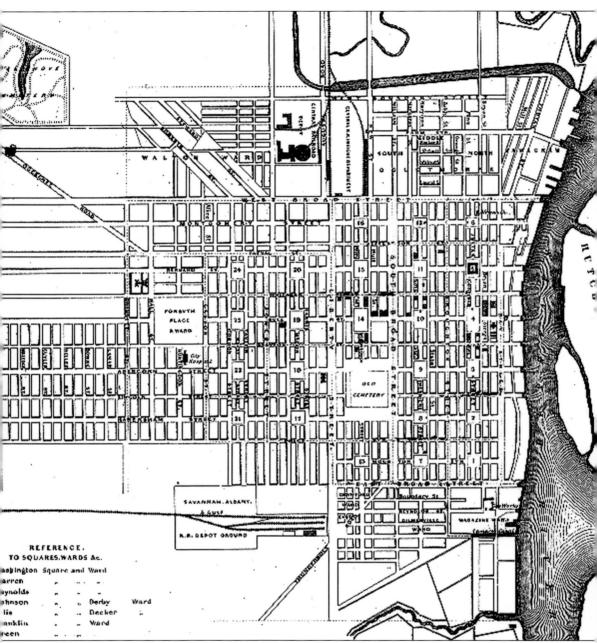

The largest of Savannah industries evolved near the river and, with the construction of railroad lines, would continue to flank the city on marginal lands to the east and west. By the middle of the 19th century, city fathers reluctantly saw the geographical necessity of redesigning the colonial plans of James E. Oglethorpe. J.B. Colton's map of the city of Savannah in 1859 shows the proposed expansion to the south of Gaston Street past Forsyth Place. This plan would be changed soon after the publication of this map by the military parade grounds. (GHS Waring Maps Collection #1018.)

26

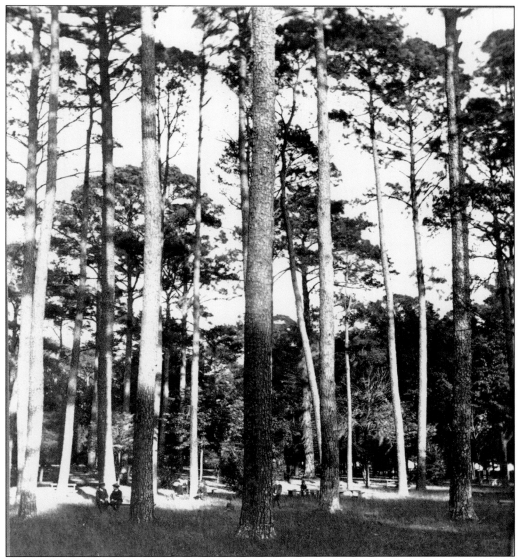

Before the extensive landscape plan for Forsyth Place was developed, the area was originally known as Hodgson Park and was a simple forest of longleaf pine and wiregrass. Reaching upwards of 100 feet from the ground, *Pinus Palustris* was admired by colonists for its strength and resistance to decay. At the turn of the century, F.V. Emerson described the virgin forest as "stately trunks rising forty to sixty feet and then spreading out their dense foliage which joins above like the arches of a cathedral." In 1899, a strong storm would claim most of the 64 pines that remained in 1895. Note the couple in the bottom left of this 1880 scene for an idea of the scale. (Courtesy V.&J. Duncan Antique Maps, Prints, and Books.)

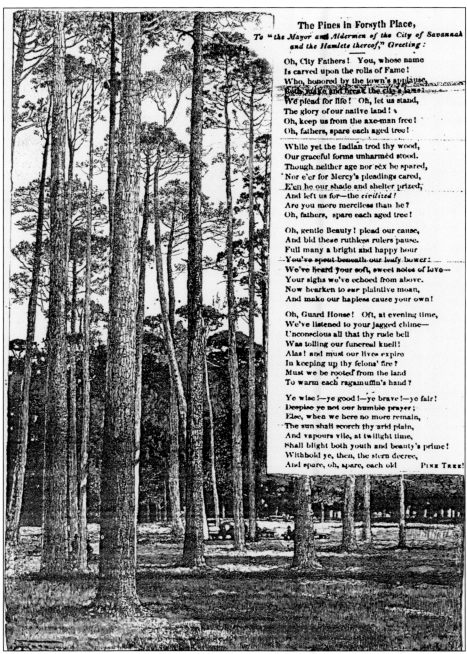

Savannah, along with many cities of the South, used the natural resources of the region to attract visitors and investors. Bold claims of "healing pines" and an accommodating climate lured the fretful inhabitants of the northern climates to escape to the invigorating forests of the South. Southerners advertised that the pine forests held a therapeutic value and were considered a "natural sanitarium" where "health reigns and sickness disappears." The poem appeared in the *Savannah Daily Republican* in 1852, in reaction to the suggestion to level the majestic trees. (Courtesy V&J Duncan Antique Maps, Prints and Books.)

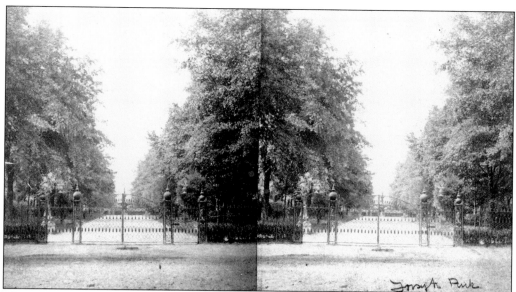

These views of the gates of Forsyth Place were taken by J.N. Willson, c. 1870. The development of the park was a critical factor in luring Savannah's growing population towards the developing southern section of the city. Despite the initial cost, the city government would make over $30,000 with the addition of the new military parade grounds and the subsequent sale of the 64 lots that comprised the old grounds. John Wickersham of New York made the $10,000 gates and fence that enclosed the park. The enclosure was reportedly built "primarily—to exclude (from the park) the herds of cattle grazing on the city commons," and was removed in 1896. (GHS #1361SG.)

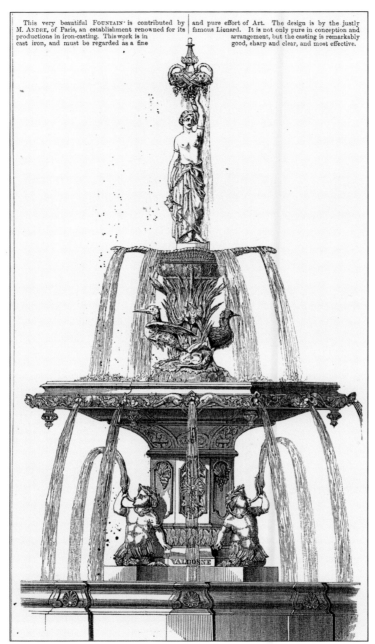

In 1858, the city contracted the services of Janes, Beebe, and Company of New York to cast in iron a fountain to be placed as the center piece of Forsyth Place. Thomas Gamble reported in 1902 that when built the fountain "was said to be the largest of its kind at that time in the United States." This etching by M. Andre, inspired by the Palace de la Concorde in Paris, was published in the *Art Journal* of 1854. The design was popular item, and versions of the cast fountain still reside in New York and Peru. Janes, Beebe, and Company (Janes, Fowler, Kirkland, & Co.) would succeed and provide ironwork for the dome of the United States Capitol. (Courtesy V. & J. Duncan Antique Maps, Prints, and Books.)

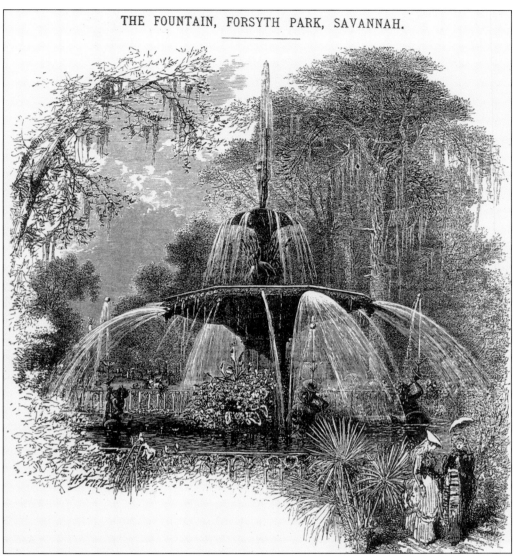

The water was turned on with the construction of the basin and installation of the fountain by contractor H.D. Headman. The *Savannah Morning News* reported, "Barring the fact the tritons, like some of our own stump speaker, spout a little too strong, it does admirably." This romanticized illustration was published in *Appleton's Journal*, April of 1872. (Courtesy of GHS.)

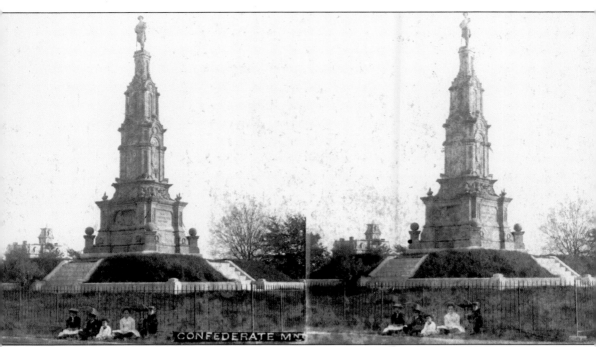

CONFEDERATE MN

The public response to the original Confederate Monument, a stone figure of "Judgement" on the pedestal and "Silence" beneath, was so somber and funereal that it was replaced in 1879 with financing by G.W.J. DeReene. The redesigned bronze of a Confederate soldier is seen above *c.* 1890 in the now familiar setting for a family picnic. For Savannah, public space defines the stream of monuments, parks, and squares encountering the inhabitants and visitors of the city. The exhibition of history and culture has flourished in these perforations of the cityscape, well beyond the intentions of Ogelthorpe's colonial plan. Savannah's open rooms create human eddies in the city grid, allowing one's visual perception to embrace the city with an arboreal cathedral. (GHS #1361SG.)

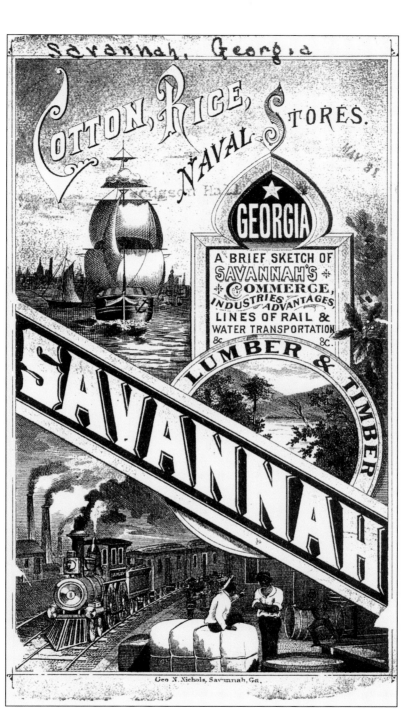

This promotional tract was published by George N. Nichols in 1884 as part of the city's efforts after Reconstruction to encourage foreign and domestic investment. While blatantly serving as propaganda, these booklets give an interesting insight into the economic acumen of Savannah's rising business class. Cotton, rice, naval stores, lumber, and timber are all given sections displaying the vitality and accessibility of the particular resource. (GHS Rare Pamphlet.)

THE INDUSTRIES OF Savannah. Ga.

PUBLISHED BY J.M. ELSTNER & CO. SAVANNAH, GA.

A. GAST & CO. LITHO. ST. L. & N.Y.

In 1886, the city of Savannah, in conjunction with the Board of Trade, compiled "The Industries of Savannah" in a continuing attempt to lure Northern capital to the region. The pamphlet contained summaries of trade, commerce, manufactures, real estate, and resources. Most of the publication was dedicated to sketches of Savannah's "representative houses," giving detailed descriptions of local businesses. (GHS Rare Pamphlet.)

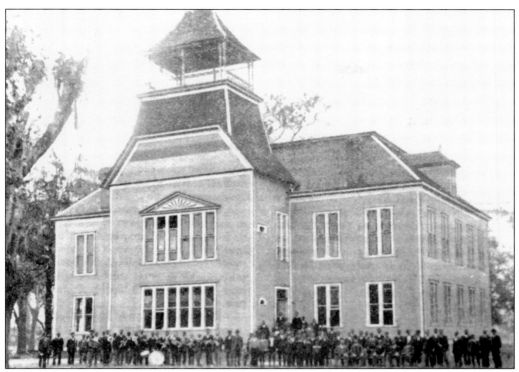

Georgia State Industrial College was established in Savannah through funding from the Federal Land Grant Act of 1890. Along with a standard curriculum, the school focused on practical training in the mechanical and agricultural arts, including classes in mechanical drawing, blacksmithing, carpentry, masonry, and painting. Meldrim Hall (above) was constructed entirely by students from designs by W. Wilson Cooke.

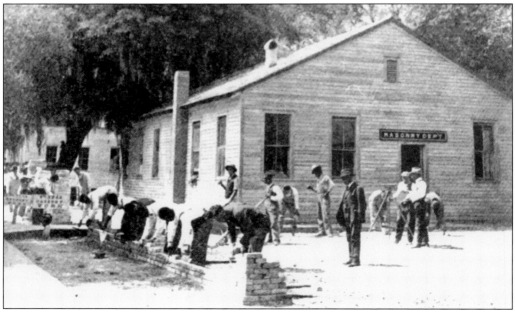

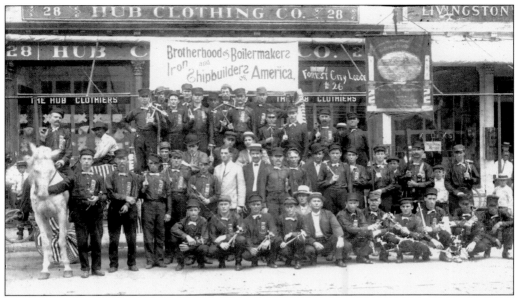

Trade unions have played a critical role throughout the history of Savannah's diverse building industries. One of the first established in the city was the Savannah Mechanics Association that included prominent early 19th century builders Amos Scudder and John Ash. In 1900, there were more than 15 organized groups representing hundreds of artisans from general trades to specific professions. This number would more than triple by the 1920s. Unions used the consolidation of skilled labor to establish standards, increase wages, and boycott contractors. (GHS #1361PH.)

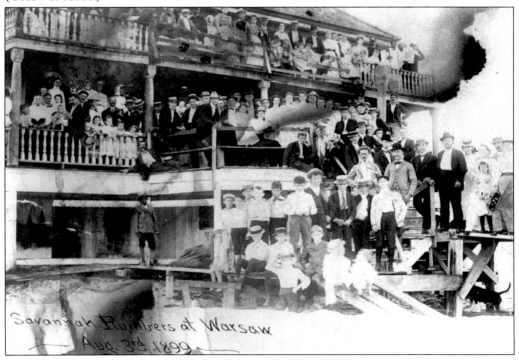

Two

MEN WHO MAKE A CITY

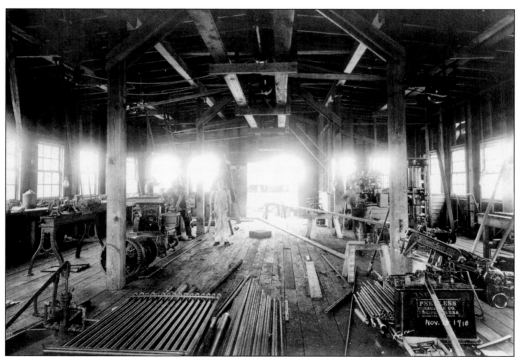

The interior of this shop in Southland Yard in 1918 would be a maze of belts used to drive the wood and metal working machines. Engines ran the drive shafts positioned in the rafters above the shop floor. The exposed belts and wheels would spin with an intense flurry, creating an environment of constant danger for the workers. (GHS #1360.)

Before the Civil War, Savannah had the wealth to support a thriving building industry. The aftermath of rubble and ashes would only encumber the inevitable reconstruction process that began in earnest for the Georgia cities of Atlanta, Columbus, and Augusta. In the fall of 1865, one Atlanta observer described a scene of, "carpenters and masons—with rubbish removers and house builders—with a never ending throng of pushing and crowding and scrambling and eager and excited and enterprising men, all bent on building and trading and swift fortune making." A few years later, Savannah would report, "Carpenters have ready employment at full wages; bricklayers and stone masons are in demand; -and the other trades each have exhibited a progressive tendency, showing a higher status for the mechanic." These pages come from the 1858 City Directory.

Born in Charleston, a young Robert D. Walker (1813–1901) came to Savannah in the 1830s. Established in 1840, the Marble and Stone Works was located on Broughton Street, and in the 1850s, it moved to a new location on York Street across from Trinity Church. Walker would be active in city affairs and provide stone for many of the cities finest structures. This bill for fire bricks bought for the Estate of E.C Anderson dates from 1877. (GHS #882.)

ESTABLISHED IN 1840.

SAVANNAH, GA., *Jany 1* 187 7

Mr I G Mills for Est. E.C. Anderson.

Bought of ROBERT D. WALKER,

DEALER IN

Marble, Slate, and Iron Mantels; Grates, Fenders, etc.

MONUMENTS AND GRAVE STONES MADE TO ANY DESIGN.

York Street, opposite Trinity Church.

MORNING NEWS PRINT.

Dec	5	To 1 Back 2 hrs Brick fixing back		2 00
			Paid	
			R D Walker	

Stone carver Archibald McAllister established his New Marble Works in the 1850s and would compete with Walker's firm until the two carvers joined forces after the Civil War. By 1880, McAllister would reopen his own yard on Broughton Street. This advertisement of Walker and McAllister appeared in the Savannah City Directory of 1870. (Courtesy GHS.)

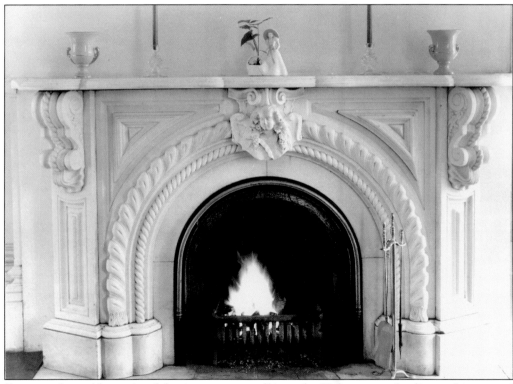

Stone work would remain a laborious process well into the 20th century, leading architects and builders to investigate materials with similar characteristics but less cost than those previously used. The skills needed to carve this mantle of Carara marble (c. 1840) for the Wetter House came from a lifetime of practice in the ancient art. (GHS Cordray-Foltz #1360.)

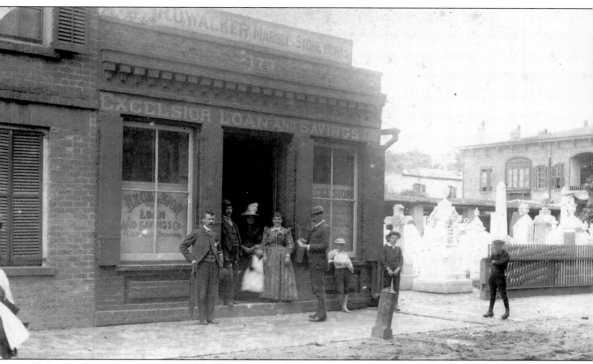

R.D. Walker's Stone and Marble Works, seen here *c.* 1890, consisted of a yard for the finished and uncut stones and a smaller shed used for cutting. A *Savannah Morning News* reporter visited the works in the winter of 1870, describing it as a "mammoth establishment" containing "$33,000 of raw material" including granite, brownstone, marble, and exotic stones from all over the world. Initially, Savannah builders imported most structural and ornamental stone from northern quarries. The Georgia marble and granite industry eventually flourished toward the end of the 19th century, supplying material for such notable structures as the New York Stock Exchange. (GHS Saussy Family Papers #1276.)

The Royal Vale Plantation bred one of the most successful early sawmills west of town. William B. Giles and Company invested a reported $70,000 in the operation, which began production in the summer of 1848. Equipped with modern planning machines, gang saws, and circular saws, the steam-powered sawmill would produce 20,000 feet of lumber per day. Note that the sizes of "planned, tongued and grooved boards" or flooring stocked by the mill are 6 to 14 inches in width.

D.C. Bacon worked with Millen, Wadley & Company before buying complete interest in the company and its steam planning mill at the corner of Price and Liberty Streets in 1873. In 1876, Bacon incorporated the business with partners William B. Stillwell and H.P. Smart, and would invest in multiple lumber operations in Georgia including Vale Royal Manufacturing Company in 1884. The new steam-operated saw and planning mill employed 200 people and was "considered one the best cypress mills in the country." Bacon and Smart retired in 1887, dissolving the firm of D.C. Bacon and Company, and soon after this, notice for the sale of the plant appeared in the *Savannah Morning News* in 1888.

This map was made by the Sanborn Fire Insurance Company in 1884. The new mill was located on the Savannah River and had ample access for ships and railroad, despite the fact that the surrounding area was "covered at high water." The Sanborn Company would use these maps to document existing structures and property for insurance claims in the event of fires and storms. Sawmills were highly susceptible to fire, and this map points out that the "roof timbers and interior [are] protected with coating of asbestos."

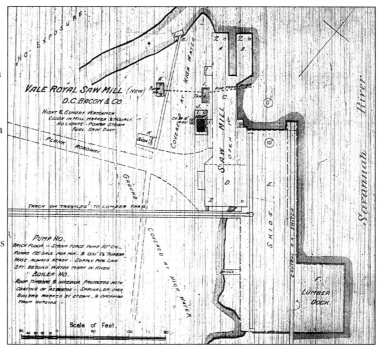

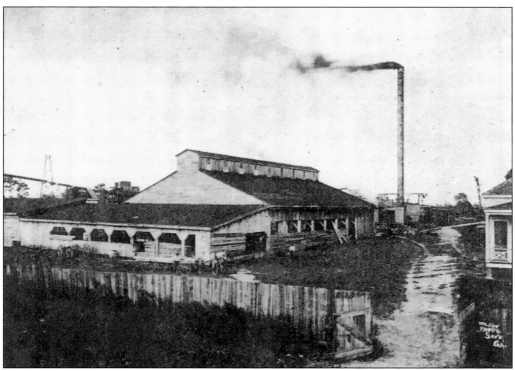

The Vale Royal Mill is pictured here in 1895 from *Fruits of Industry*.

Albert S. Bacon and brother, D.C. Bacon, were children when the Bacon family arrived in Savannah around 1850. The boys' father, Major Edwin Bacon, originally of Walthourville County, Georgia, was a lawyer and legislator. Albert was "shot in the face" during the Battle of Gettysburg and suffered "frequents headaches" from the wound until his death. Scene here c. 1890, with his characteristic goatee and mustache, the soldier and lumberman has been suggested by some scholars as the model for the Confederate Monument.

Albert's sons, Hal and Albert C., would join their father in the family business in the 1880s. Hal H. Bacon, seen in this photograph c. 1900, was one of eight brothers and sisters born in Savannah. Hal served as vice-president of the Liberty Bank and Trust while working for the lumber firm.

A.S. Bacon started business with partner J.F. Brooks in the 1870s. The firm brought in local lumberman B.P. Johnson until 1887, when Albert would become sole proprietor of Bacon, Johnson & Co. and the planning mill then located Liberty and East Broad Streets. This advertisement established the new firm of A.S. Bacon & Sons in 1891.

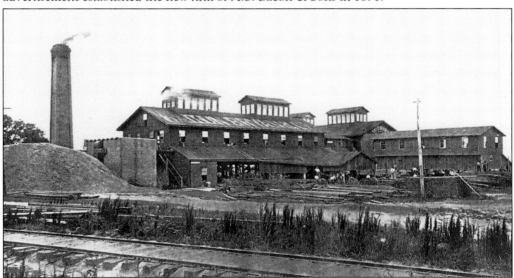

On the rail lines east of the city near the river wharves, the Bacons constructed a new mill, seen in this picture from *Fruits of Industry* in 1895. Albert's brother, Dewitt Bacon, purchased the lots on Liberty Street and dismantled the old mill in 1890. Interestingly, the *Savannah News* reported that Dewitt had hired architect Albert S. Eichberg to design a "plunge and swimming pool" for the site that would include, "complete Turkish bath accommodations, and provide for vapor, Russian, and other systems of baths." He would forgo the exotic undertaking and build a series of row houses on the property.

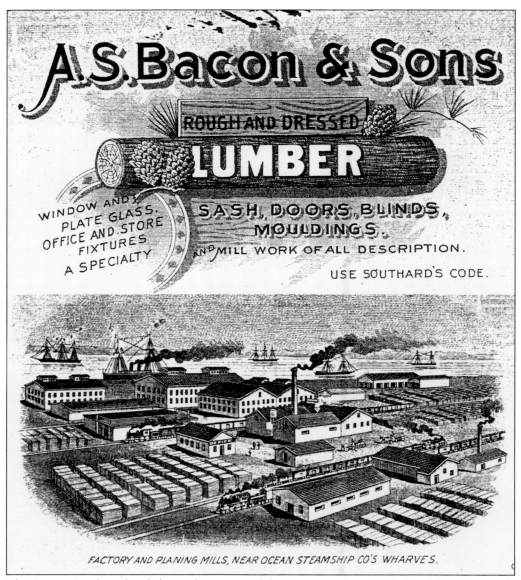

FACTORY AND PLANING MILLS, NEAR OCEAN STEAMSHIP CO'S WHARVES.

This interesting letterhead shows the extent of the Bacon yards in 1910. In addition to rough and dressed lumber, the mill produced moldings, cabinets, and some furniture, but specialized in the production of sash, door, and blind. The $60,000 operation included a steam-drying kiln and employed more than 100 hands by the turn of the 20th century. The engraver for this view must have never visited the yard, barring the mountains located across the river on Hutchinson Island. (GHS Central of Georgia Railroad #1362AN.)

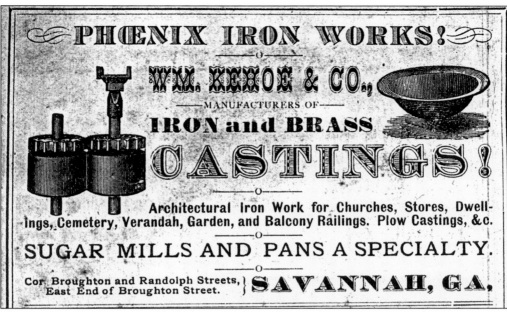

Phoenix Iron Works was established in 1873 by William Kehoe and E.F. Monahan. A seasoned veteran, Monahan previously helped establish the Savannah Iron and Brass Foundry with mechanics James Manning and Alvin Miller. The popularity and versatility of architectural ironwork is shown in this advertisement of 1879 from the City Directory.

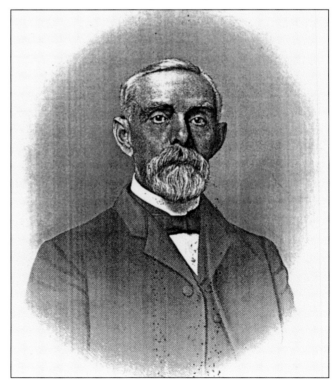

Escaping famine and oppression in Ireland, the Kehoe family arrived in Savannah when William was only nine years old. A renowned eccentric in his older years , William Kehoe was described by one of his grandchildren as wearing a "black alpaca in winter and white linen in summer" and having "never, until his death, coming to the dinner table without his pongee coat." Kehoe is pictured here c. 1895.

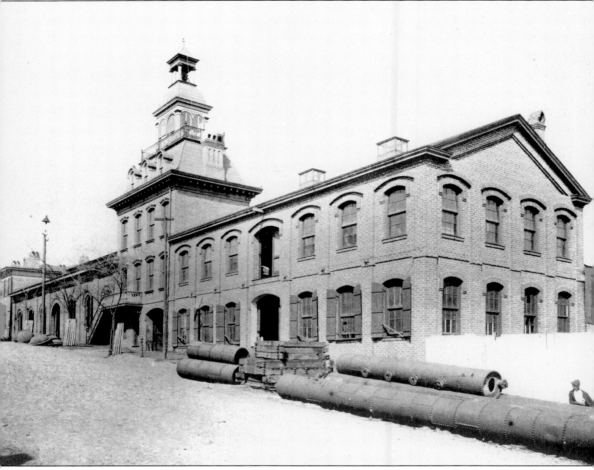

Phoenix Iron Works dissolved in 1883, and as sole proprietor, Kehoe constructed a new pattern shop to add to the works on Reynolds and Randolph Streets. Described as one of the largest and best equipped of the day, the shop specialized in sugar mills, pans, shafts, and architectural ironwork. The firm stayed at this location until World War II, when it constructed a new works on the river capable of marine repair. In this view of the works in 1893, the foundry is on the left side of the cupola, and the pattern shop is in the foreground. Note the sugar pans on the far left of the picture. (From *Artwork of Savannah*, 1893.)

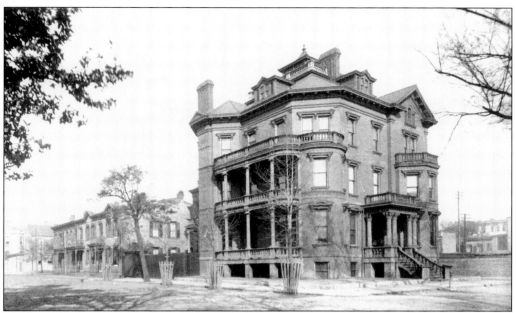

Architect Dewitt Bruyn provided designs for the Kehoe's mansion on the corner of State and Habersham Streets, built at a cost of $25,000 in 1892. In front of the house on Columbia Square some years later, an effigy of Kehoe would be set afire by workers attempting to form a union. Kehoe, a cultured man with a "weakness for cupolas," reportedly faced the mob and said "Go home, lads, you've had your fun. Have a good supper, say a prayer for me and be at work on time in the morning. More of this heathen display and you can warm your winters in a cold foundry." (From *Artwork of Savannah and Augusta*, 1902.)

ROSE, CURTIS & CO.,

Contractors and Builders,

STEAM

CARPENTER SHOP,

AND

PLANING MILL,

Cor. W. Broad and Gwinnett sts.,

SAVANNAH, GA.

Manufacturers of

DOORS, SASHES, BLINDS,

Mouldings, Brackets, Ballusters,

Newell-Posts, Hand-Railing, Columns, and Scroll Work,

OF EVERY DESCRIPTION.

By the 1870s, the city would be home to more than two dozen lumber mills and timber factors. This advertisement for Rose, Curtis and Company in 1871 places their "steam carpenter shop" on the corner of West Broad and Gwinnett. Steam power made these shops possible by running circular saws, band saws, jigsaws, and lathes needed to create stock materials. Pattern Books would provide the shops with popular designs and details used to prefabricate wooden building products "of every description."

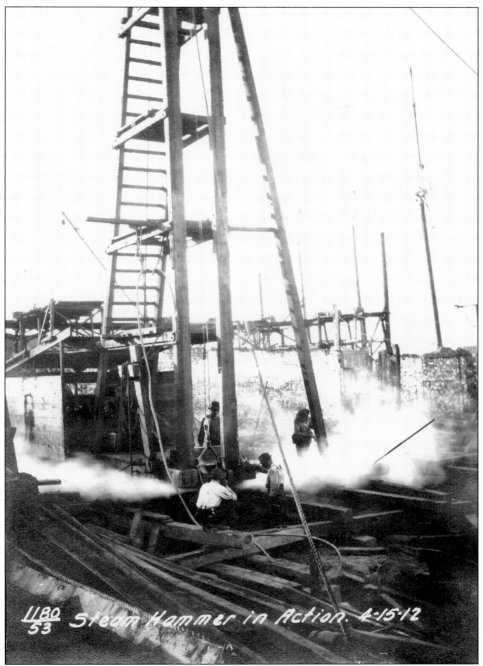

1180
53 Steam Hammer in Action. 4-15-12

Steam power made construction more powerful and efficient. This view is of a steam hammer driving 48-foot pine pilings into the shore of the Savannah River for the foundation of the Riverside Powerhouse in 1912. Sand and clay soils near water pose the threat of "liquefaction," a process in which solid ground is transformed into unstable mud. To anchor the building, dozens of pilings were driven down through the upper layers and connected with a network of iron and concrete. This single machine saved weeks of work on this job. (GHS #1381.)

Painter Andrew Hanley came to Savannah 1871 and began work with partner William McKenna. He would open Hanley's Paint and Oil Store on the corner of Whitaker and York Streets by 1878. The four-story building was stocked with "a full line of building materials" including paints, wallpaper, hardware, and moldings. During the Hogan Dry Goods fire of 1889, the cupola of the building caught fire, and a "large amount of oils, paints, and other combustibles exploded." This drawing of the store is from "Industries of Savannah 1886." (GHS Rare Pamphlets.)

Chris Murphy started as a painter in 1865 and would soon meet partner Charles Clark. In this 1870 advertisement, the painters offer services in "gilding, graining, marbling, glazing, and paper hanging." Artisans used "faux finishes" too visually transform a typical building material into the exotic and expensive. Murphy would be quoted years later about his business saying, "I fear no competition as to the class of work I will do."

This is receipt for "repairing plastering at dwelling" for the Estate of Ephriam Scudder in May of 1876. Plaster of Paris was the dominant treatment for interior finishes in the 19th century and would remain popular until the widespread use of sheet rock products during the middle of the 20th century. Nearly a lost art, plasterwork artisans created the crown moldings and ornamental ceiling medallions that gave 19th-century interiors much of their beauty. The artistry of plasterwork enhanced the ornamental ceiling medallions and crown moldings giving interiors much of their beauty. Tully worked under plasterer Issac Brunner before starting this firm with William Grady. (GHS Scudder Family Papers #719.)

Machine shops and foundries were essential for all of the trades in building by providing tools, materials, and machinery. J.W. Tynan came to Savannah in 1862 from Virginia and established his business in 1871. Tragically, after the new construction of his foundry, the building burned in the fire of 1883. After reconstruction, the Tynan machine works were described in 1886 as a "landmark." The works are seen here on the corner of West Broad and Canal as #53 in this 1891 *View of Savannah* by Augustus Koch.

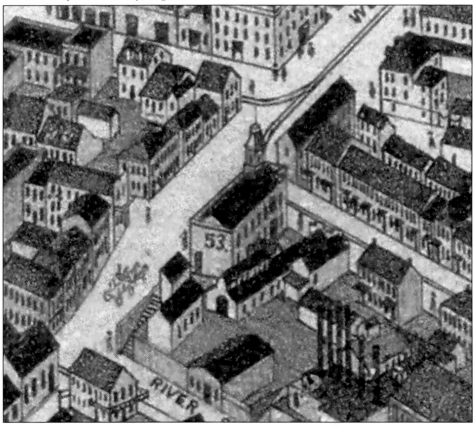

Originally, the cheapest and most popular roofing material for buildings was wooden shingles. Slate, tin, zinc, galvanized iron, and ceramic tile would begin to dominate the market by the 19th century as a result of city fire regulations restricting the use of flammable materials on buildings and roofs. Lightweight and durable, tin was described by Thomas Jefferson in 1821 as "the most desirable cover in the world." In 1866, John. J. Maurice advertised this prestigious list of clients in the City Directory.

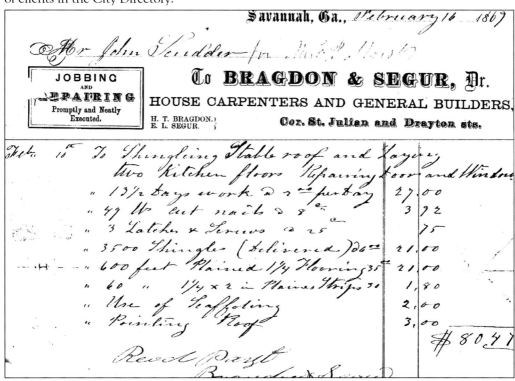

This 1869 bill accounts work done by Bragdon & Segur for John Scudder. With the expansion of the city, the business of building houses became a large percent of construction, and within a decade of this bill, dozens of workmen would advertise for this market. The work on this job included "laying two kitchen floors" and "repairing door and windows." Note the cost of materials in 1869. (GHS Scudder Family Papers #719.)

ROURKE'S
IRON WORKS, ——

·JOHN ROURKE & SON, Prop'rs.

610 to 634 Bay St., East, Cor. E. Broad....

Iron and Brass Founders,
Blacksmiths and Machinists.

Heavy Forgings a Specialty

AGENTS—Atlas Engines and Boilers, Blake Steam Pumps.

Iron Railings, Pulleys, Shaftings, Hangers, Injectors, Lubricators, Steam Gauges, Steam and Water Fittings, Iron Pipe, Valves, Set Screws, Etc., Etc.

MACHINERY REPAIRS OF ALL KINDS.

John Rourke began his career as a molder with Monahan, Parry, & Company. Rourke began building his own shops on the east end of Bay Street around 1871 under the name Novelty Iron Works. In 1876, the iron and brass foundry was in full production and added the "no.4 Patent Sturtevant blower" that was described by the *Savannah Morning News* as the only one "used in this section of the country." Notably, the foundry would cast the bell for the Old City Exchange. (GHS J.N. Wilson VM#1375.)

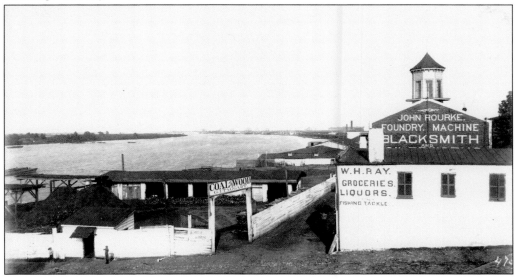

Located at No. 2 Bay and River Streets, the foundry gained the nickname "Gibraltar." Rourke's Iron Works remained in business for over 60 years, and at the age of 90, Rourke was still working eight hours a day. "A man should take a certain amount of exercise a day," Rourke was quoted as saying in 1927. Commenting on his health he said, "and work, and plenty of it, is always beneficial." This image, taken from the railroad tracks on River Street, show the familiar building around 1880. (GHS #1361PH.)

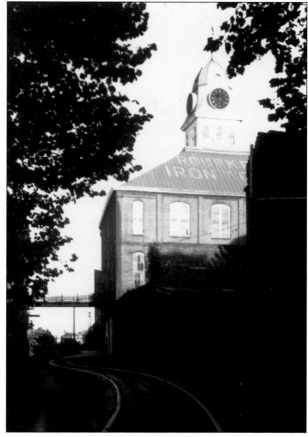

Foundries created incredible amounts of heat during casting, thus requiring large windows and attic cupolas to encourage ventilation of the building. The cupola distinguishes Rourke's building in this drawing from the Augustus Koch's *Bird's Eye View of Savannah 1891*. The awkward iron tanks of The Mutual Gas and Light Company are seen as #66, built on the walls of Fort Wayne.

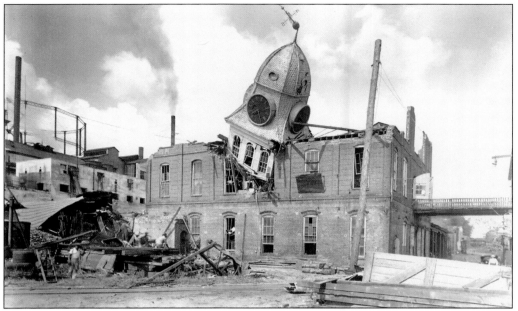

Rourke's Iron Works is seen after the Hurricane of 1942.

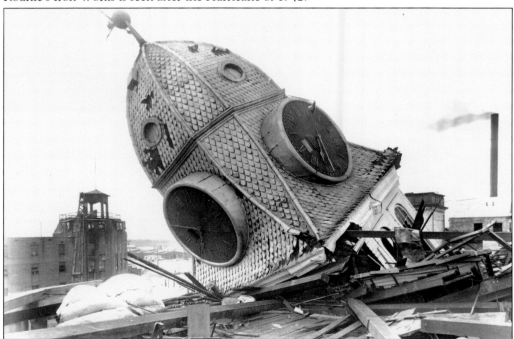

The tireless Rourke was recorded as one of Savannah's most "stirring citizens." A true patriot, Rourke would celebrate the Fourth of July at the foundry with his employees by displaying his eagle, "George Washington," and reading aloud sections from the Declaration of Independence. The holiday would end by the firing of a small cannon. These pictures were taken after the Hurricane of 1942, which destroyed the trademark cupola and clock tower. (GHS Cordray-Foltz #1360.)

R.B. Reppard established his planning mill and lumber yard around 1871 on the corner of East Broad and Huntington Streets. In 1878, Reppard was reported to have shipped a million feet of yellow pine in the months of March and April. Milling sizable timbers to specific widths required the ability to accurately control the logs as they approached the saw blade. The industrious Reppard received a patent for his "Roller Gauge" design, seen in this 1879 advertisement from the Savannah City Directory.

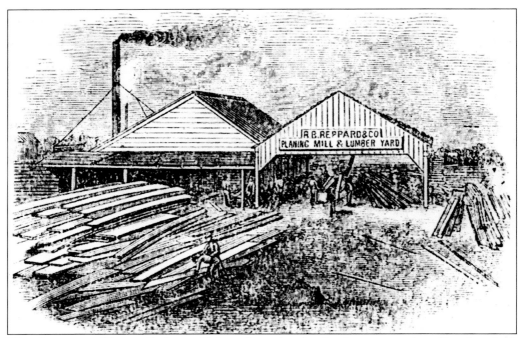

This depiction of Reppard's first mill dates from shortly after its construction. He advertised, "we feel confident of being able to undersell all competitors," due to his location directly on the rail lines.

R.B. Reppard & Co. relocated in the 1880s to a spot on the Savannah, Florida, & Western Railroad at the end of east Duffy Street. Reppard was a critical member of the industry, quoted in the *Southern Lumberman* of January 1884, recommending to Southerners, "hold on to your timber lands as long as possible." He advocated adoption of land conservation policies that would avoid the "millions of acres destroyed by the turpentine business." In this 1891 drawing by Augustus Koch, the mill and lumber pile are seen as #39.

The success of R.B. Reppard would lead to diversified investments in iron and land companies. He would eventually join W.S. Hawkins in the firm whose calling card is seen here. (GHS Willie Swoll Sawyer #713.)

J. J. DALE. **DAVID WELLS.**

J. J. DALE & CO.,

—MANUFACTURERS AND DEALERS IN—

Yellow Pine Lumber and Timber,

Planing Mill and Lumber Yard: Thunderbolt Road, Corner
Liberty Street,

SAVANNAH. ▪ ▪ ▪ **GEORGIA.**

Founded in 1866 by J.J. Dale, John McDonough Sr., and James H. Hobson, the firm was located at the corner of Price and Charlton Streets. In 1872, under control of Dale and new partner David Wells, the steam planning mill at the corner of Thunderbolt Road and Liberty Street was shipping an "average 300,000 feet per month." A *Savannah Morning News* reporter that toured the building commented, "elegant specimens of scroll and turn work of red cedar were shown to us." He continued that the "firm was awarded a medal for work of this character last year." (GHS Scudder Family Papers #719.)

PLANED LUMBER AND FLOORING ALWAYS ON HAND.

YELLOW PINE,
WHITE PINE, POPLAR,
BLACK WALNUT,
MOULDINGS,
WOOD TURNING,
SCROLL SAWING, &c.

Savannah Morning News Print.

Savannah, Ga., May 26th 1876

E. Heidt, Admx
Mr E. E. Buchner, for Estate of E. Scudder

Bought of **J. J. DALE & CO.,**

Manufacturers of and Dealers in

LUMBER, SHINGLES, Etc.

Lumber Yard and Planing Mill Cor. Thunderbolt Road and Liberty St.

1876						
May 19	To 8 pcs 3 × 4	136 ft @ 15 =		2	04	
	" 18 inch boards	303 " 12 =		3	64	
	Dr				65	6 33
22	" 22 pcs 1 × 3	98 ft @ 15 =		1	47	
	" 5 " 3 × 4	127 " "		1	91	
	" 34 inch boards	526 "		6	31	
	Dr Buchner			1	13	10 82
26	" 5 pld 1¼ in flooring	62 ft @ 3¢		1	86	
	" 1 pc 6 × 12	60 " 15 =			90	
	Dr				25	3 01
						20 16

Rec'd Payment June 17/76
J J Dale & Co
p. S. C. Roberts

In 1888, the success of the lumber industry had depressed prices throughout Georgia. Dale, then a 25-year veteran of the business, joined A.S. Bacon and R.B. Reppard to meet with Savannah's railroad officials to negotiate a settlement over excessive tariffs. Despite a bitter dispute, after the meeting Dale was quoted as saying, "to use a cracker phrase, we whooped 'em out." In his later years, Dale would serve as an officer of the Ogelthorpe Savings & Trust Company and chairman of the Chatham County Commissioners. This advertisement of 1891 was one of several firms of which Dale was part.

Like most Savannah lumber mills, Dixon, Johnson, & Company established their works near the rail lines. Formed by N. Dixon, B.P. Johnson, and John A. Sullivan, the mill advertised its lumberyards contained "500,000 feet of boards, all of which thoroughly seasoned." The works are seen here in 1871.

James M. Dixon, the father of Merrit W. Dixon, was a prominent lumber dealer and Savannah citizen. A city alderman, James served on the city Water Commission and the committee in charge of the construction of City Hall. Merritt became president of the Dixon Lumber and Construction Company by the turn of the 20th century. Alderman Dixon is pictured here in 1901 from Thomas Gamble's *History of the City Government*.

David Wells spent a lifetime in the Savannah lumber industry, beginning with J. J. Dale & Company in the 1870s. Wells is pictured here as a city alderman in 1901 from *History of the City Government*.

J.J. McDonough rose to prominence in Savannah through the influential creations of his father, John McDonough. Educated at Xavier College in New York, John. Jr. would begin his career as a clerk at his father's lumberyard. With his subsequent success in business, the rise of John Jr.'s political career began culminating with his election as mayor of Savannah in 1891. McDonough would serve a second term in the office, espousing upon his reelection, "Municipal government is a business matter, pure and simple, and to inject into it political partisanship and bigotry, is to prove it false to the sacred obligations, which we have assumed this day." J.J McDonough is pictured here in 1890 from Charles C. Jones, *History of Savannah*.

John Jr.'s brother, Henry A. McDonough, apprenticed in a machine shop in Augusta before joining the family business in Savannah. Henry was reported to have help construct the *Native*, one of Georgia's first locomotives. He would work at the family's foundry and sawmill for many years, until his health required him to retire. The McDonough family would play a significant role in the longleaf pine harvests and building industry during the end of the 19th century. Henry is picture here from *Memoirs of Georgia* of 1895.

Trained as a machinist in Philadelphia, John McDonough and his wife, Mary, would move to Augusta where their boys would be born. After settling in Savannah, the senior McDonough established the lumber company around 1860 and would be succeeded by his son, J.J. McDonough, in 1879. In 1890, the works reported doing $100,000 of business and "turned out about 25,000,000 feet of lumber annually for domestic and foreign markets." The mill would produce all of the moldings and interior wood for the Desoto Hotel and the Chatham County Courthouse. Number 52 in this Augustus Koch drawing is McDonough's establishment, and next door is #51, Dale, Dixon, & Company.

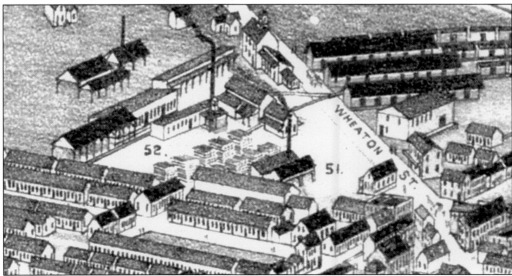

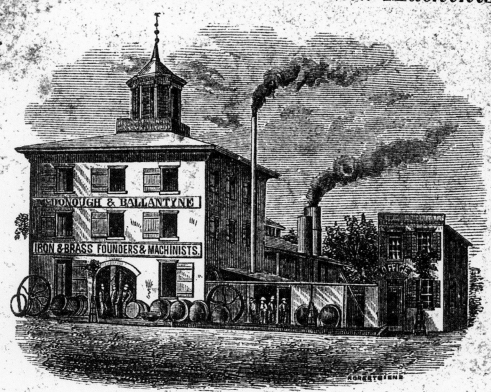

McDONOUGH & BALLANTYNE

Iron and Brass Founders and Machinists.

East Broad Street, near S. F. and W. Ry.

Savannah, - - Georgia.

McDONOUGH & BALLANTYNE

IRON & BRASS FOUNDERS & MACHINISTS.

OFFICE

Architectural Iron Work. Sugar Mills and Pans Specialties.

In 1866, John McDonough Sr. collaborated with Thomas Ballantyne to organize a foundry and machine shop that would hold a leading place among Savannah's businesses. Ballantyne apprenticed at a foundry in Scotland before reaching the United States, where his considerable skill as a moulder soon led him to Savannah in 1859. Local iron founder A.N. Miller, impressed with Ballantyne, hired him to supervise his shops before the Civil War. Miller's foundry and machine works would continue under Ballantyne's expertise during the Federal occupation of Savannah, specializing in marine repair. The new foundry on East Broad Street, seen above, was built around 1867 and was advertised as being capable of "Iron Fronts for building purposes at Northern Prices." In addition to architectural work, the firm would succeed through lucrative contracts from the Central of Georgia Railroad.

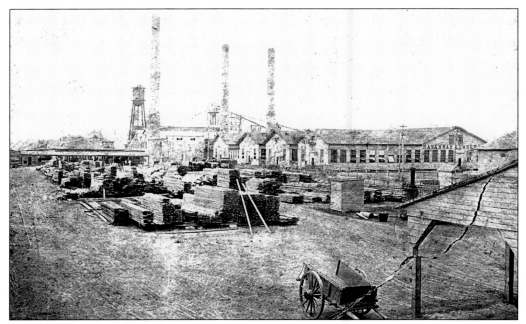

Seen here is Savannah Lumber's exterior view, *c.* 1890.

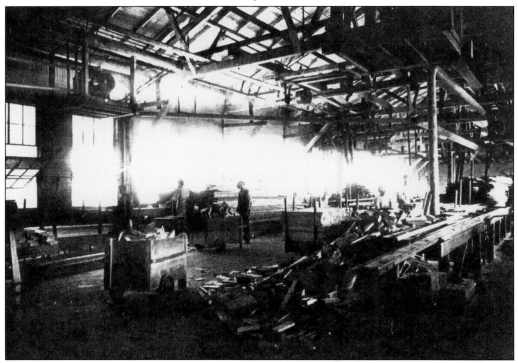

This view of Savannah Lumber, *c.* 1895, shows the yard and mills located at 54th and Montgomery Streets. One of Savannah's oldest suppliers of building materials, the John G. Butler Company would buy out Savannah Lumber a few years after these pictures were taken. (GHS #136-20.8.4061.)

After years of wasteful conflict, many of Savannah's leading lumber companies consolidated to
form the Southern Pine Company of Georgia. This ad from the City Directory dates from 1899.
Note the familiar list of names associated with the firm.

69

In 1926, the United States Forest Service published this book in an attempt to encourage Southern landowners to replant idle lands and conserve the longleaf pine. The federal government finally encouraged legislation to arrest the growing reality of timber famine in the United States, the culmination of years with unchecked abuse.

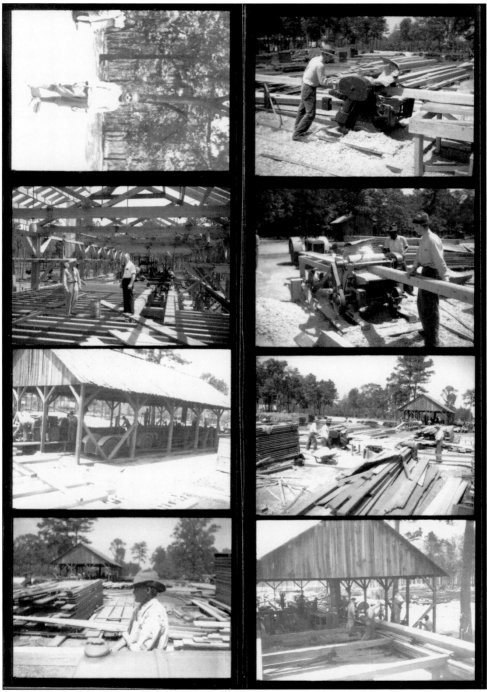

Consolidation and size saved some Savannah lumber mills after the peak of the Georgia harvest. The remaining tracts of timber, consisting of mainly smaller second growth trees, were considered uneconomical to the larger producers. New "Pecker Mills," like this one seen in Richmond Hill c. 1930, sprouted to capitalize on the stands. (GHS Cordray-Foltz #1360.)

71

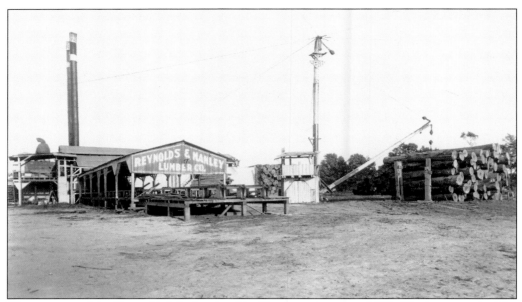

The exterior of the Reynolds-Manley Lumber Company is seen c. 1930. The boom and cables were used to move the timbers from yard to mill.

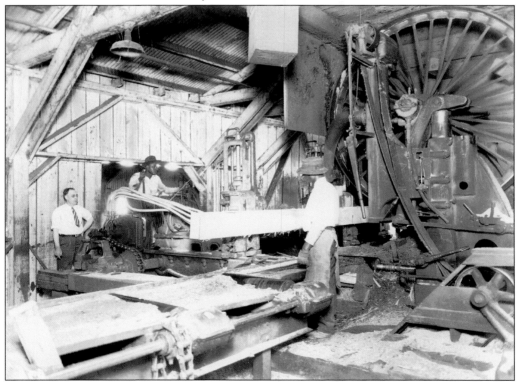

The Reynolds-Manley Lumber Company was located at Montgomery and 54th Street next to the rail lines, opposite the John G. Butler mill. This photo, c. 1930, shows the band saw in action. (GHS Cordray-Foltz 1360.)

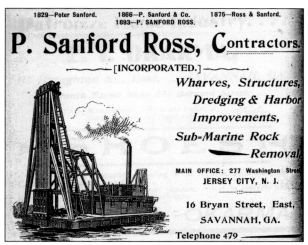

The evolution of specialty contractors to meet the needs of marine construction have always played a role in making the Savannah River more accessible. The challenge of bridge, dock, and wharf construction requires expensive equipment to meet the dangers of shifting currents and tides. Beginning in 1829, the P. Stanford Ross marine construction company began operations in New Jersey under founder Peter Stanford. Advertising here in 1900, the drawing shows a retrofitted tug boat and steam pile driver capable of laying multiple poles simultaneously.

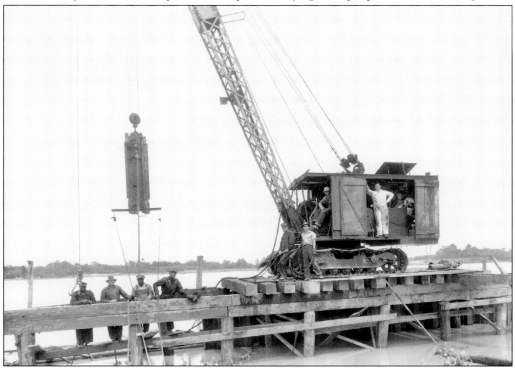

These workers at Union Camp in the 1930s constructed a railroad trestle by using a crane to drive the pilings into the mud. While slower than steam equipment, the practice of using large weights raised above then released on the pilings has been utilized for centuries. (GHS Cordray-Foltz #1360.)

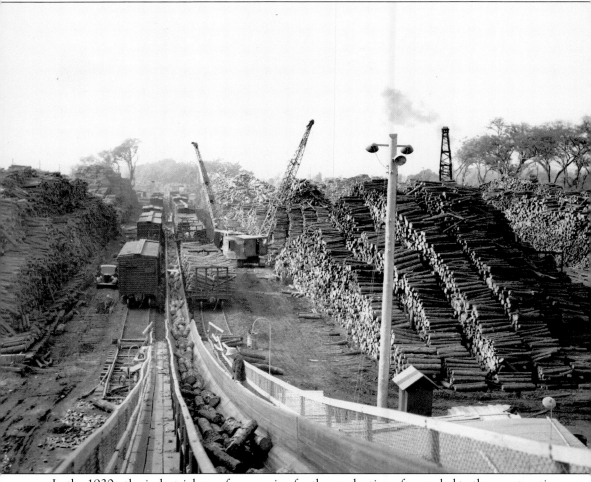

In the 1930s, the industrial use of young pine for the production of paper led to the construction of the Union Camp Plant, located on the site of the original Hermitage Plantation. The largest of its kind in the world, the plant construction costs would top ten million dollars. Near the time of this photo, *c.* 1940, the plant was consuming 110 cars of wood—like the ones seen in this yard—every day. (GHS Cordray-Foltz #1360.)

Three

ARCHITECTS
AND DRAFTSMEN

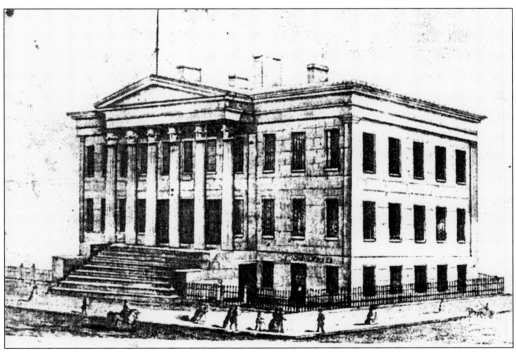

It took six months to wheel the 15-ton granite columns—seen in this drawing of the United State's Customs House—from the river up to Bay Street. Nearly five years in construction, the John Norris–designed building was a significant technical and architectural achievement for the industry of early Savannah. Norris chose local master builder Mathew Lufburrow as foreman of the work. (GHS Waring Maps #1018.)

Savannah Nov 30th 1846

Sir

On examination of the bricks offered
(to be used in the construction of the Custom House) by
Mr Bryan and by Mr Willett of the firm of Lawton & Willett
all of this City, and with whom you authorised me to make
a Contract with, I find they will not answer, being too
soft and easily broken and not complying with the
Specification I sent them, and upon which they made
their offers

I have examined the bricks made
by Mr McAlpin and by Mr Minus of this City and
offered by them, and either of them will answer for
the Custom House, being hard grey brick

Mr McAlpin offers to supply 190,000 at $12 per thousand
delivered on the Custom House Lot

Mr Minus offers to supply 190,000 at $11.50 per thousand
delivered on the Custom House Lot

I am Very Respectfully
Your Obedient Servant
John S Norris Architect and
Superintendent of Savannah Custom House

Honbl Robert J Walker
Secretary of the Treasury
Washington
D. C.

While controversy surrounded the acceptance of John Norris over Georgia architect Charles S. Cluskey, Savannah citizens were impressed with the $150,000 building. This letter of 1846 details the architect's examination of brick for the building, with estimates received from local manufacturers. Apparently, Norris sent specifications to several local brick yards, which in turn produced specimens. (From National Archives.)

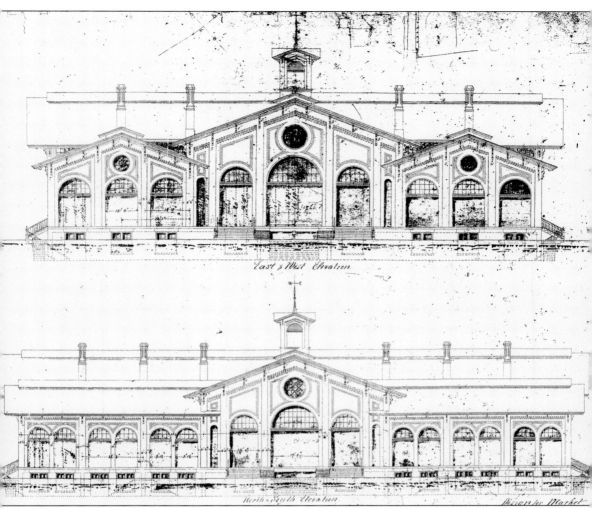

East & West Elevation

North & South Elevation

The city appropriated $75,000 for a market structure to replace the former building, having long been dilapidated and increasingly too small. Architects Martin P. Muller and Augustus Schwaab submitted plans for the new City Market (seen above) in the summer of 1870. During the two years of construction, the building "cost vastly exceeded expectations" and eventually totaled over $160, 000. Excavation of the old Market had reveled failing arches in the basement floor that would be replaced and strengthened with iron girders. Schwaab, trained as an engineer, worked on designs for the Central of Georgia Railroad, including the arched railroad trestles on West Boundary Street. (GHS Architectural Drawings #1361MP.)

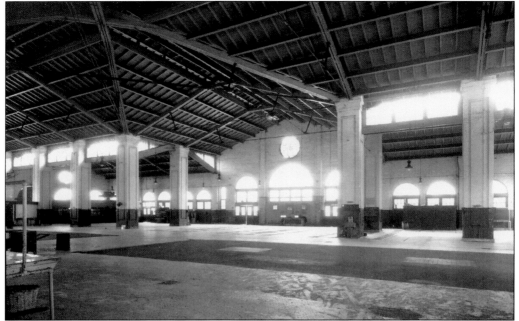

Encompassing 33,000 square feet of space for the merchants of Savannah, Mayor Screven described this building as "Roomy, capable of being kept in the highest condition of cleanliness, with ample ventilation . . . it is devoid of of the repugnant characteristics commonly belonging to public markets." Carpenter James C. Saltus would lead the construction that included iron work from the foundries of both S.W. Gleason and McDonough & Ballantyne. These interior views were taken in the 1940s. (GHS Cordray-Foltz #1360.)

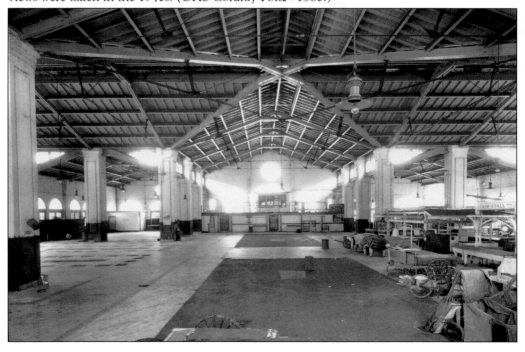

In 1875, Detlef Lineau, a founding member of the American Institute of Architects, designed Hodgson Hall as a new library for the Georgia Historical Society. Financed by sisters Margret T. Hodgson and Mary Telfair, the building was a memorial to Margret's late husband, scholar William B. Hodgson. (From *Artwork of Savannah and Augusta.*)

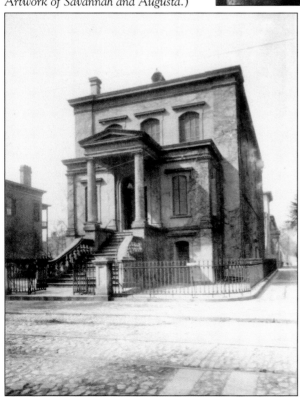

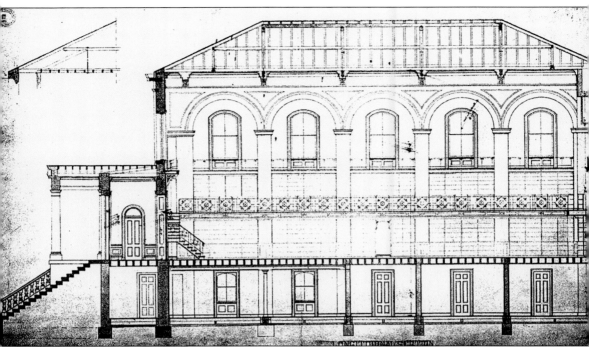

Edward and J.W. Jones would supervise construction of a 20,000-volume library using local stone artisan Archibald McAllister and castings from McDonough & Ballantyne. Seen in this cross-section of the building, Lineau's use of clerestory windows on the east and west of the structure would provide the required natural light for reading. Despite a storm, Hodgson Hall would open to a full house at the dedication in February of 1876. (Courtesy of the Avery Library of Columbia University.)

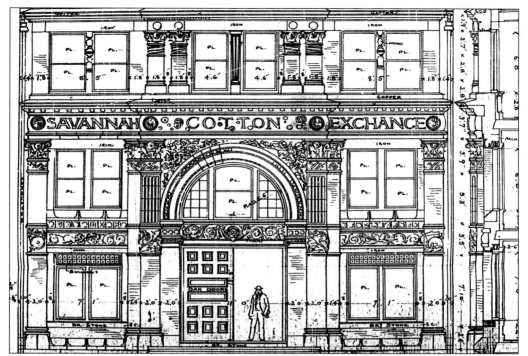

William Preston, a native Bostonian, entered a drawing in a competition for the design of the Savannah Cotton Exchange under the pseudonym, "Devonshire." Sponsored by the Savannah Chamber of Commerce, the structure was built in response to the dominant role of cotton in the economy. Preston arrived in Savannah in 1886 to accept the commission and began a stretch of works resulting in many of city's finest buildings. This view shows Preston's design of the entrance to the building. (William G. Preston Collection, Boston Public Library, Reproduced courtesy the Trustees of the Boston Public Library.)

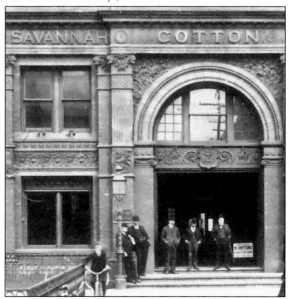

This view from 1902 shows the front facade of the Savannah Cotton Exchange. (From *Artwork of Savannah and Augusta*.)

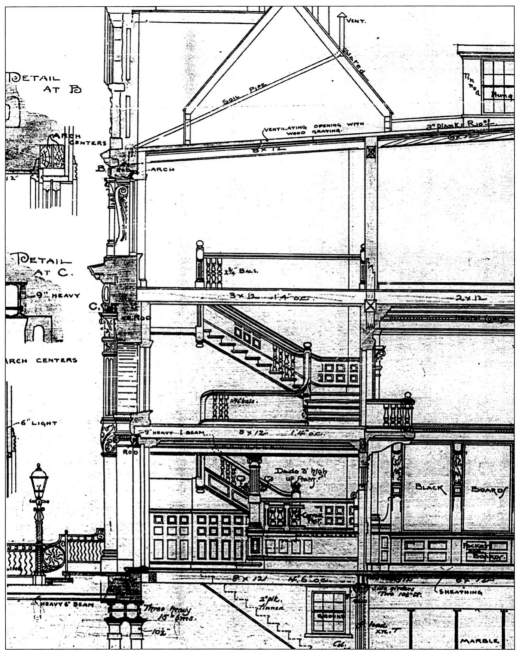

A technical master, Preston had little difficulty complying plans for the required passage on the existing public slip. The elevated building would cost over $40,000 by completion and would showcase the talents of mason W.F. Chaplain, carpenter A.J. Aylesworth, and founder John Rourke. (William G. Preston Collection, Boston Public Library, Reproduced courtesy the Trustees of the Boston Public Library.)

82

Savannah Ga. May 11ᵗʰ 1886

The Committee met at four o'clock at the office of Messrs Munn & Anderworth &c all members were present. Detailed plans and specifications received from Mr Preston Architect were inspected and discussed. The Secretary was instructed to advertise for proposals as follows. Times & News. every other day. until 24ᵗʰ inst

Proposals Wanted

PROPOSALS WANTED.

BIDS will be received until noon MONDAY, May 24th, inst., including labor and material, for the entire work, or for any one or more portions, grouped as follows, for the Savannah Cotton Exchange Building:

MASONRY, BRICK, TERRA COTTA, PILING and PLASTERING.

CARPENTER WORK.

TINNING, COPPER and SLATE WORK.

PAINTING and GLAZING.

PLUMBING, GASFITTING and PIPING.

IRON WORK.

Plans and specifications can be seen at the Exchange. The right is reserved to reject any and all bids.

By order of the Building Committee.

E. F. BRYAN,
Superintendent.

The foregoing sketch from the inception of this movement to date was read and Confirmed by the Committee. The meeting then adjourned until tomorrow morning at twelve O'clock noon

E. F. Bryan Supt
& Secty to the Bldg Com

During his work in Savannah, Preston would use many different local mechanics and artisans, but the Boston Terra Cotta Company manufactured his characteristic terra cotta. Preston even solicited the Tiffany Glass Company for estimates on the Cotton Exchange. This page is from a minute book compiled by committee members during the construction process. It shows the ad published in the *Savannah Morning News* seeking bids. (GHS MS#686.)

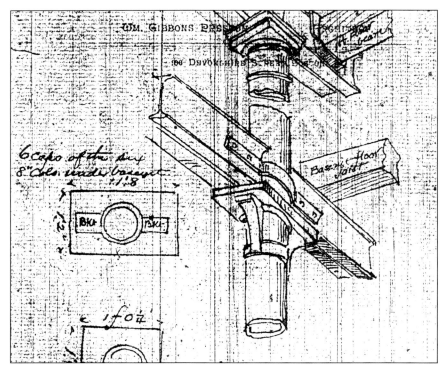

To support the heavy load of the building's masonry, Preston redesigned the iron for the basement floor, but John Rourke had already cast the columns. This drawing shows his detail sketch for the brackets added to support the first floor I-beams. Years later, the building would settle from weakness in a lime mortar used under the column piers, about which Preston voiced complaints to the committee during construction. (William G. Preston Collection, Boston Public Library, Reproduced courtesy the Trustees of the Boston Public Library)

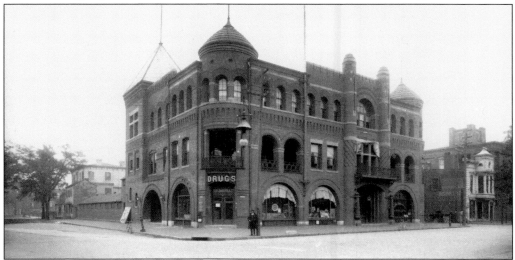

Preston's plans for the 1893 Savannah Volunteer Guards building included specially designed wood and iron trusses. The building is seen here in 1902. (From *Artwork of Savannah and Augusta*.)

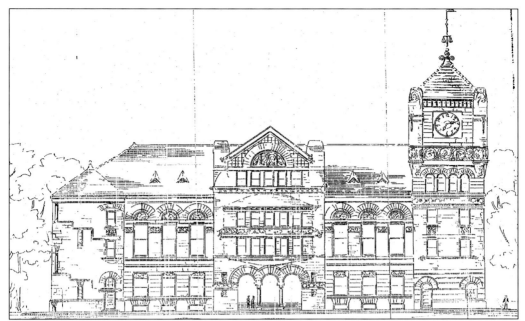

This drawing shows Preston's design of the Chatham County Courthouse. Preston, A.S. Eichberg, and contemporaries would be responsible for the widespread use of terra cotta in the buildings of Savannah. Produced mainly in in Boston, New York, New Jersey, and eventually Atlanta, the material was advertised by one New Jersey manufacturer as "the cheapest—with which architectural effects can be produced." Light, durable, and fireproof, the molded designs allowed for ornamentation that would have previously been financially prohibitive. The terra-cotta panel for the clock tower is seen in Preston's design of the Chatham County Courthouse. (William G. Preston Collection, Boston Public Library, Reproduced courtesy the Trustees of the Boston Public Library.)

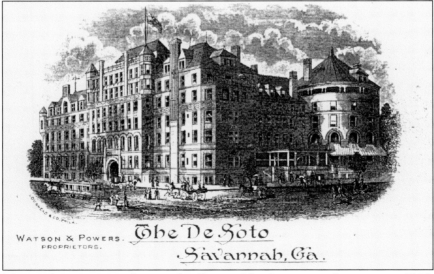

One of Preston's greatest works was the Desoto Hotel, seen in this print *c.* 1900. (GHS Vertical File.)

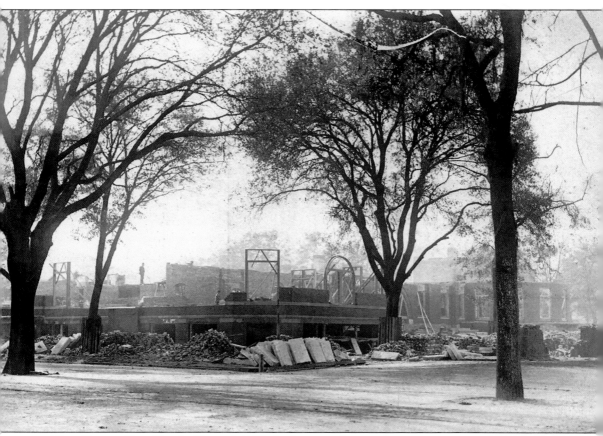

The Hogan Dry Goods Fire of 1889 broke out during the construction of the Desoto Hotel. Flames leapt from the consumed Independent Presbyterian Church across Chippewa Square, cascading embers down onto the wooden scaffolding around the site. Workers scrambled along the flammable maze extinguishing any spot of ignition. In this 1889 photo by James Silva, the masons are constructing the characteristic arches of the Desoto's ground floor. (GHS James S. Silva VM#2126.)

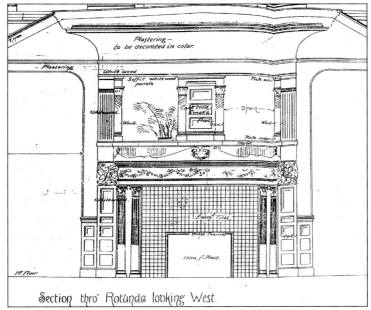

Preston's drawings show his attention to materials and detail. This characteristic would lead him to design even the smallest item of a buildings interior and exterior. This shows the design and finish of the fireplace on one side of the Desoto's rotunda, c. 1939. (William G. Preston Collection, Boston Public Library, Reproduced courtesy the Trustees of the Boston Public Library and GHS Cordray-Foltz #1360)

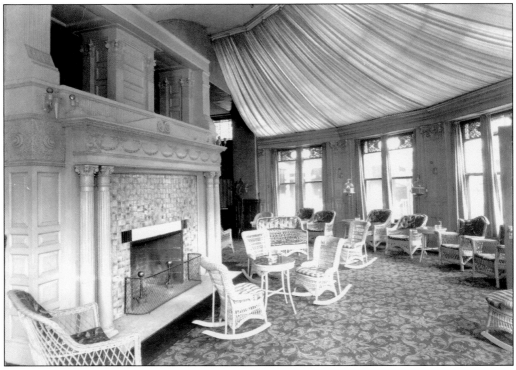

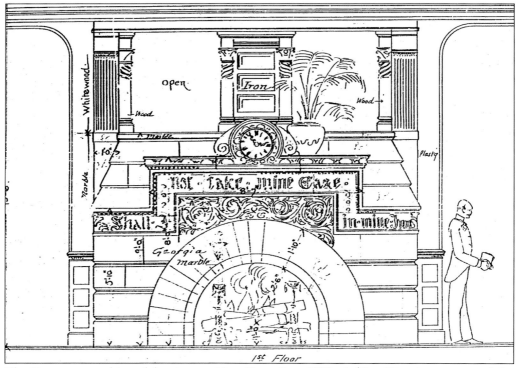

The Desoto opened in celebration on New Years Eve, 1889. A $1 million investment of the Savannah Hotel Company, the Desoto advertised "330 rooms with all modern conveniences." Promoted for years as a premier resort destination, the elegant hotel helped the city receive the designation, "New York of the South." (Courtesy of the Boston Public Library and GHS Cordray-Foltz #1360.)

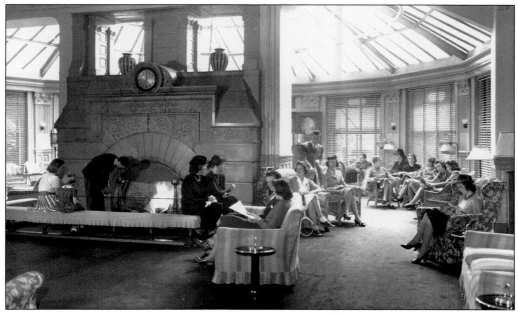

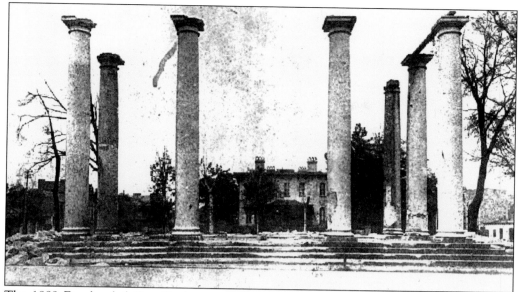

The 1889 Fire leveled First Presbyterian Church, and Preston was hired to reconstruct the substantial edifice using the few depictions that existed. A *Savannah Morning News* reporter that witnessed the 180-foot tower ablaze wrote, "it at first bent a little beneath the force of wind, and then it fell to the ground with a terrific crash." (GHS Savannah Historical Research Association #994.)

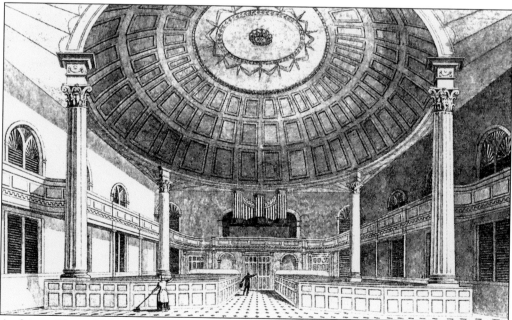

Architect Henry Urban would assist William Preston in the reconstruction of the church in 1890. William Dean Howell praised the new building declaring, "one might well seem to be looking at it in a London street, but the interior is of such unique loveliness that no church in London can compare with it." This print shows the original interior dome of Independent Presbyterian Church around the middle of the 19th century. (GHS Prints #1361PR.)

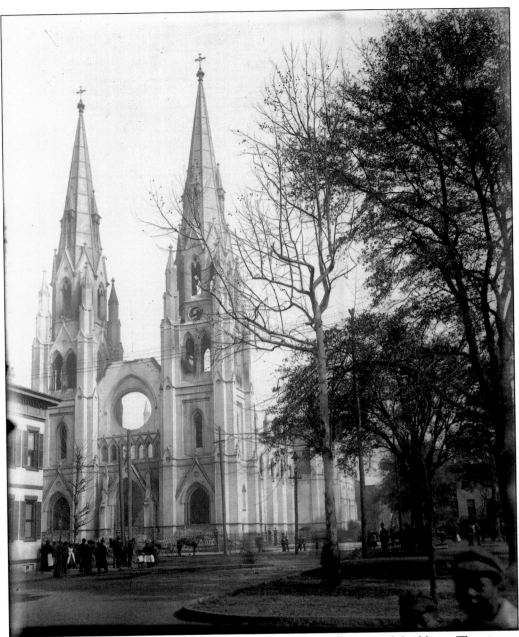

Fire has resulted in the destruction and reconstruction of many Savannah buildings. The picture above shows a haunting hollow facade of the Cathedral of St. John the Baptist the day after it was gutted by fire on Feburary 6, 1898. "Years of work by scores of men burned in the presence of thousands in less than two hours," reported the *Savannah Morning News* on the tragic events. (GHS #1378.)

Designed by Baltimore Architects Baldwin & Price, construction began in 1872 under the supervision of W.G. Butler. The Savannah Brick Manufacturing Company supplied the one-and-a-half million bricks needed, and R.D. Walker executed much of the stone work. The 26-foot cast iron columns seen scattered on the burned floor of the church were done by McDonough and Ballantyne. (GHS #1378.)

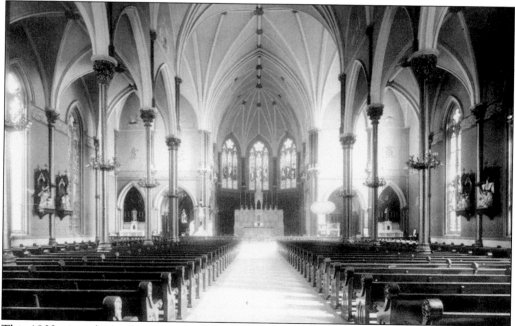

This 1902 view shows the interior of the cathedral after its reconstruction. (From *Artwork of Savannah and Augusta*.)

FAY & EICHBERG

ARCHITECTS

3 BULL STREET,
Over W. U. Telegraph Office,
SAVANNAH, GA.

The firm Fay & Eichberg started in Atlanta before establishing offices in Savannah by 1886. Fay returned to Atlanta in 1889, but Eichberg remain in Savannah, becoming one of the city's most prolific architects. He is credited with the design of nearly two dozen commercial and residential buildings, including the Central of Georgia Railroad offices and the Telfair Hospital for Women. While described as a "prominent secret order man," little more is known of the architect's life in Savannah. Eichberg apparently left Savannah abruptly in 1898, and is rumored to have "lost his sight." He died in Atlanta on May 15, 1921.

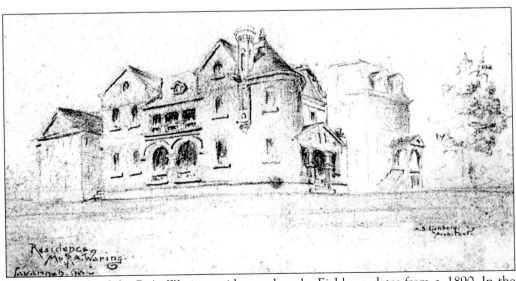

This rare sketch of the R.A. Waring residence, done by Eichberg, dates from c. 1890. In the 1890s, the heavy Romanesque style was made popular in Savannah by architects Eichberg and Preston. (GHS Hartridge #1349.)

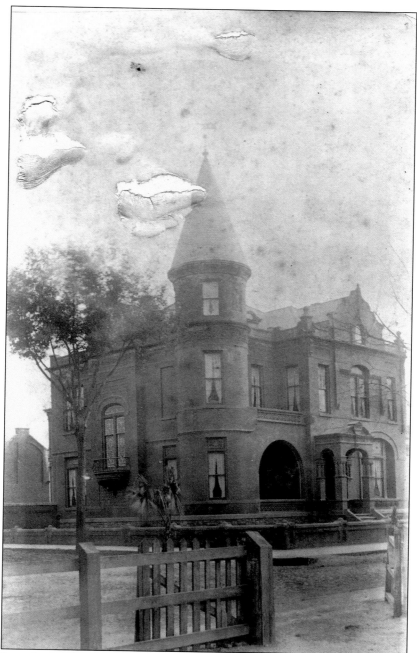

A.S. Eichberg designed this home at 700 Drayton Street for Lewis Kayton in 1887. This view of the residence, *c.* 1890, shows the $45,000 building on a prestigious lot facing the Park Extension. In high demand, the architect talked to the *Savannah Morning News* about his business in 1891. The reporter commented, "judging from the number of parties that have consulted him with a view towards building and the number of orders he has already in hand, he thinks the prospect for next year a very bright." Eichberg's new draftsmen, young Hyman Witcover, is believed to have contributed to the design. (GHS Saussy Family Papers #1276.)

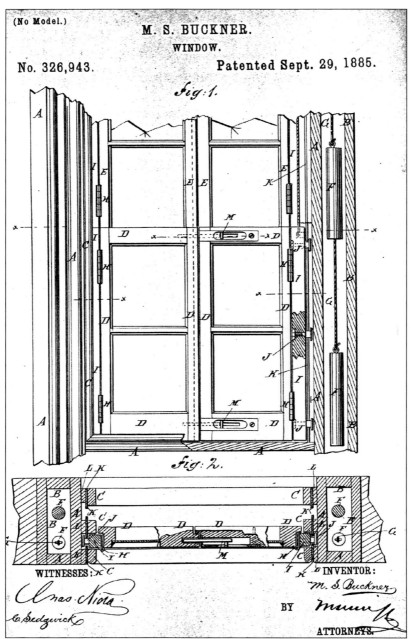

M. S. BUCKNER.

WINDOW.

No. 326,943. Patented Sept. 29, 1885.

Fig. 1.

Fig. 2.

WITNESSES:
Chas. Niola.
C. Sedgwick

INVENTOR:
M. S. Buckner
BY
ATTORNEYS.

Throughout the country, the building industry began to encourage design innovations in the home and in business. In 1885, after years of design and review, U.S. and international patents would be awarded to "Buckner's Double Action Sash Window." Marion Scudder Buckner designed the window to swing on hinges in addition to sliding like a normal weighted sash window. This, Buckner professed, aided in the "washing, opening, and closing of windows." Tragically, Buckner would die before he could find any willing manufacturer of the complex design, and the rights for the window would be sold off by his heirs for $800. (GHS Scudder Family Papers #719.)

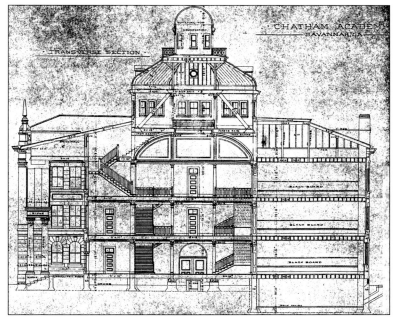

Working under Preston, Henry Urban supervised many of the senior architects commissions in Savannah. In 1901, Urban prepared this design for the new Chatham Academy, including a "rotating top observatory" to house a 6-inch telescope the school had purchased several years prior. The board, due to financial constraints, rejected the $8,000 cupola. (GHS Architectural Drawings MS#134.)

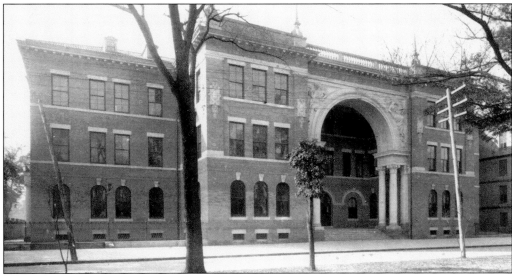

The old Chatham Academy building dated from the early 19th century and was described by contemporaries as having "an air of consequence and gentility." Arson, to cover up a burglary, was suspected in the fire that destroyed the structure in 1899. Interestingly, the board of trustees considered a reconstruction of the historic structure, but this was abandoned with the acceptance of Urban's 1901 design. This picture shows the facade of the building as it appeared in 1902. (From *Artwork of Savannah and Augusta*.)

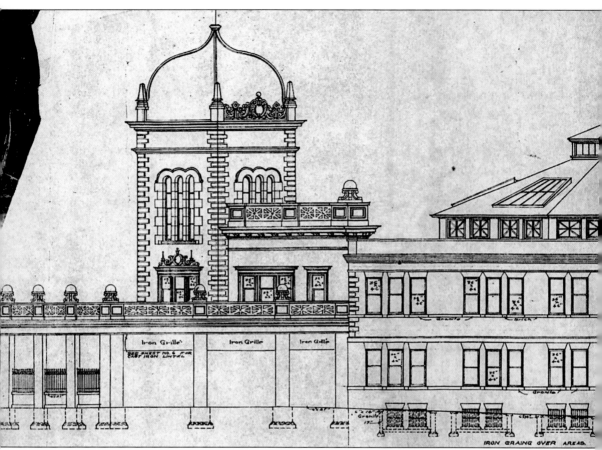

The architecture of the urban rail station reached its peak during the early years of the 20th century. Railway design required technical and mechanical expertise that was provided to Savannah by South Carolina architect Frank Milburn. Built on a 12-acre plot on West Broad Street, the structure was purchased by the Savannah Union Station Company from the city in

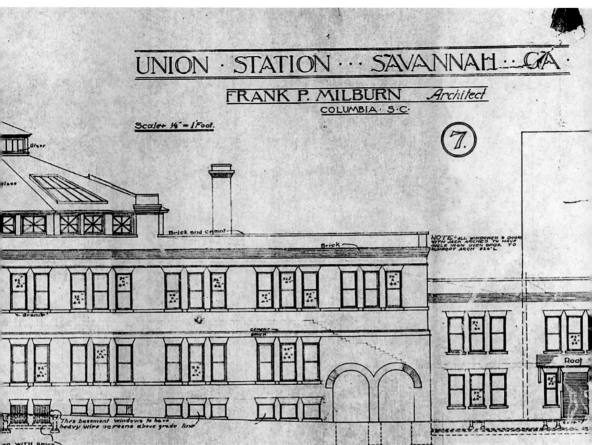

UNION · STATION ··· SAVANNAH ·· GA ·

FRANK P. MILBURN Architect
COLUMBIA · S·C·

Scale+ ⅛" = 1 Foot.

⑦

1900 for just less than $10,000. It is seen in this drawing from 1902. Designed to emphasize the "importance of the railway traveler," the building costs reached $200,000—$700,000 with approaches—by the time of its opening at midnight May 24, 1902. (GHS Architectural Drawings #1361MP.)

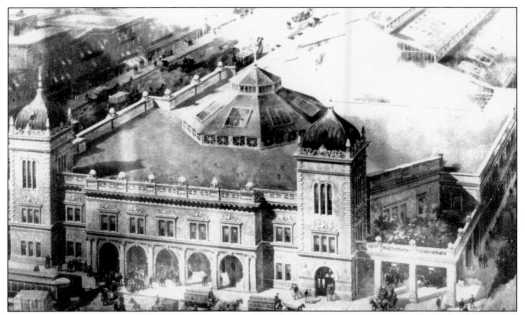

This stylized drawing of Union Station was done before the construction of the building and published in *Art Work of Savannah and Augusta* of 1902.

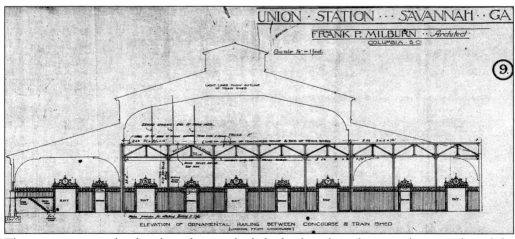

The construction of railroads and train sheds had ushered in the age of iron and steel for 19th-century architecture. This drawing shows Milburn's designs for the ornamental railing and between the concourse and shed. (GHS Architectural Drawings #1361 MP.)

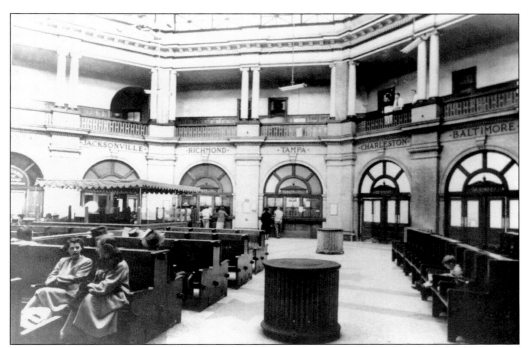

These views, *c.* 1940, show the interior rotunda and shed area in back of the building used for arrival and departure. In its 61-year life span, it would greet the arrival of three presidents, soldiers of two wars, and countless travelers. With the decline of the railroad transportation in the 20th century, the exotic grandeur of Union Station would be lost to the modern convenience of an interstate highway ramp. (GHS #1361PH.)

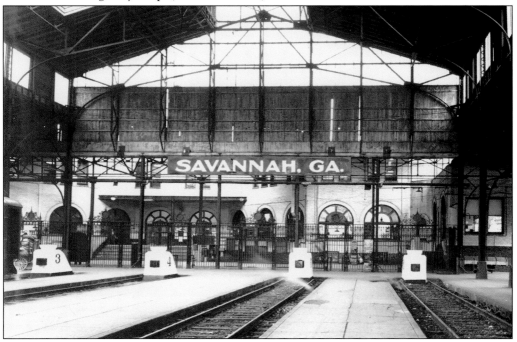

Hyman Witcover trained under A.S. Eichberg before establishing his own firm in 1900. His credits include the 1912 Masonic Temple, considered a visual and technical masterpiece of the day and using an air-conditioning system of his design. In the 1920s, his talents earned him the position of Inspector General for the Scottish Rite of Freemasonry in Georgia. He would do architectural consultation for temples throughout the Southeast. (GHS Rare Pamphlets.)

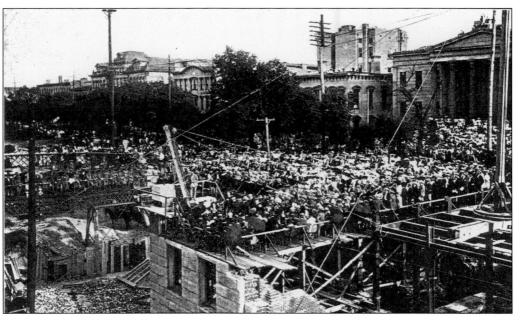

Despite the notable loss of the 100-year-old City Exchange, the cornerstone of the new Whitcover-designed City Hall was laid with grand anticipation on August 11, 1904. (GHS Rare Pamphlets.)

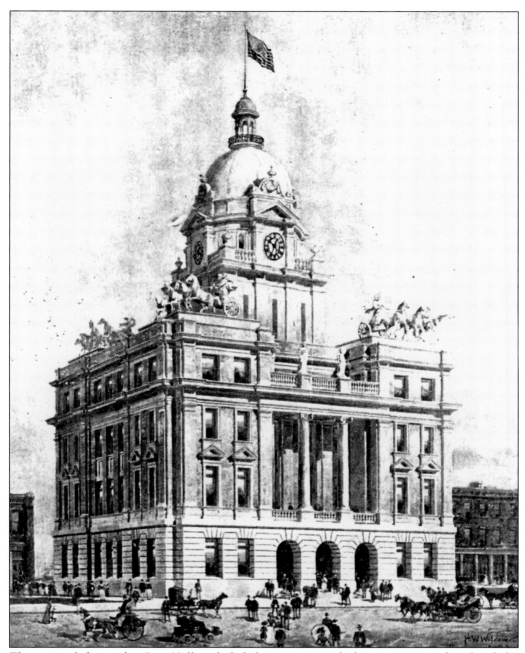

The original design for City Hall included the monumental chariots seen in this sketch by Witcover. Exclusion of the four chariots was reportedly due to financial constraints, but some suggest the intervention of a higher power. (GHS Rare Pamphlets.)

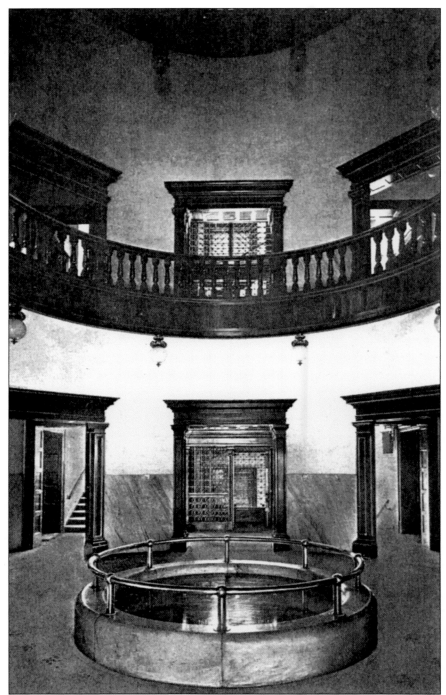

Finally completed in 1905, the new City Hall would cost in excess of $250,000. Commenting on the structure, Mayor Herman Myers described it as "a monument to the progressive spirit that marks the Savannah of today." John Rourke's foundry would supply the structure's ironwork. This view from 1905 shows the rotunda. (GHS Rare Pamphlets.)

Four

FOR HEALTHFULNESS, ACCESSIBILITY, AND GENERAL DESIRABILITY

Building in Savannah has, on many occasions, resulted in archeological discovery. This human skull, found in the extension of the Riverside Station in 1926, could be the remains of a soldier fallen in the Battle of Savannah in 1779. (GHS SEPCO#1381.)

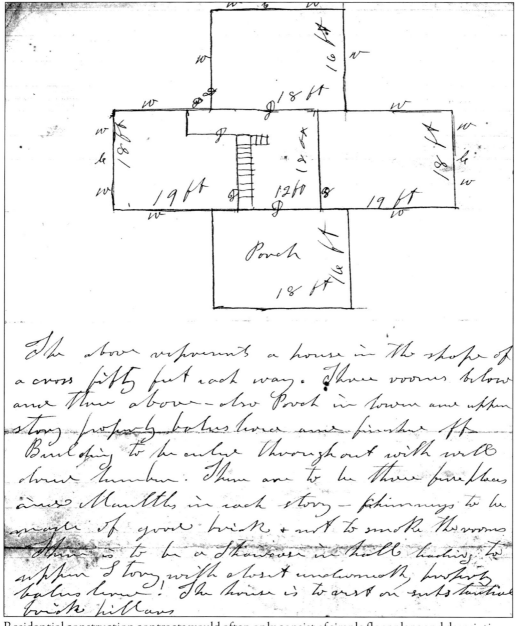

Residential construction contracts would often only consist of simple floor plans and descriptions. Master builders could extrapolate the finishing details from this type of vernacular plan. Allison Smith signed this contract in February of 1881 to build a house for A.G. Wright at a cost of $1,565. (GHS Wright Family Papers #882.)

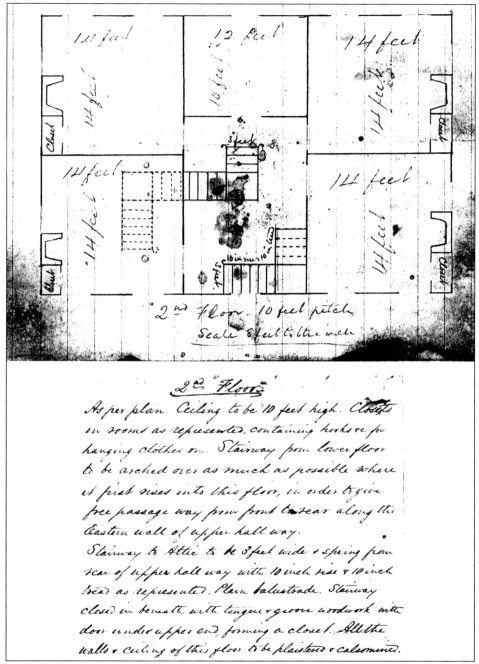

In this house plan, *c.* 1880, the owner diagrams the 2nd floor of a house. The plans show a simple four square with central hall design, allowing for bedrooms on all corners of the house that include fireplaces and closet with hooks "for hanging clothes on." Despite the impact that pattern books would have on the exterior ornamentation of homes during this time, the interior layout of most houses would retain the classic hall-parlor formula. (GHS George Wayne Anderson Papers #846)

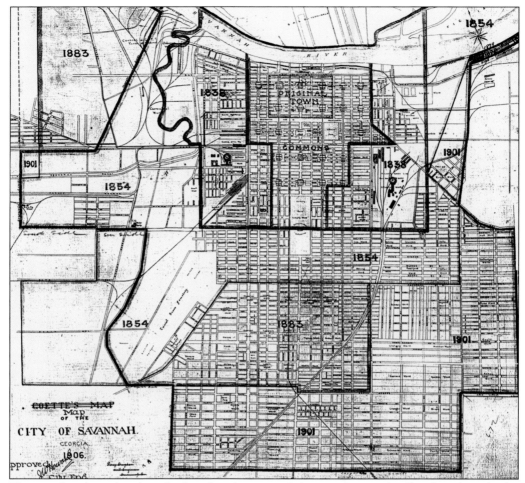

The much admired colonial plan for the city of Savannah was finally altered with the introduction of Forsyth Place and the Park Extension. This 1906 map, drawn by Percy Sugden and J.B. Howard, shows the incorporation of land into the city limits by the year of annexation. (GHS Engineering Maps #5600EN-90.)

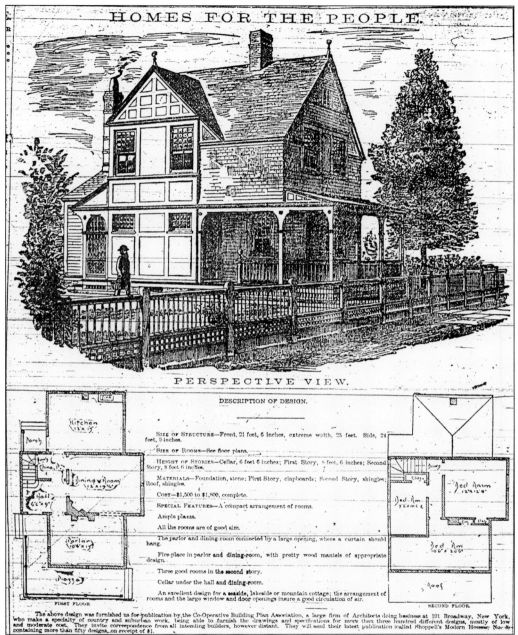

PERSPECTIVE VIEW.

DESCRIPTION OF DESIGN.

Size of Structure—Front, 21 feet, 6 inches, extreme width, 25 feet. Side, 24 feet, 9 inches.

Size of Rooms—See floor plans.

Height of Stories—Cellar, 6 feet 6 inches; First Story, 8 feet, 6 inches; Second Story, 8 feet 6 inches.

Materials—Foundation, stone; First Story, clapboards; Second Story, shingles; Roof, shingles.

Cost—$1,500 to $1,800, complete.

Special Features—A compact arrangement of rooms.

Ample piazza.

All the rooms are of good size.

The parlor and dining-room connected by a large opening, where a curtain should hang.

Fire-place in parlor and dining-room, with pretty wood mantels of appropriate design.

Three good rooms in the second story.

Cellar under the hall and dining-room.

An excellent design for a seaside, lakeside or mountain cottage; the arrangement of rooms and the large window and door openings insure a good circulation of air.

FIRST FLOOR

SECOND FLOOR

The above design was furnished us for publication by the Co-Operative Building Plan Association, a large firm of Architects doing business at 191 Broadway, New York, who make a specialty of country and suburban work, being able to furnish the drawings and specifications for more than three hundred different designs, mostly of low and moderate cost. They invite correspondence from all intending builders, however distant. They will send their latest publication called Shoppell's Modern Houses, No. 9, containing more than fifty designs, on receipt of $1.

In the spring of 1887, the *Savannah Morning News* began publishing house designs by the Co-Operative Building Plan Association and R.W. Shoppel of New York. These were advertised as "Homes for the People." Shoppel was part of the ubiquitous proliferation of pattern book publications of the late 19th century that included books by Woodward & Thomson, Bicknell & Comstock, and Pallisner, Pallisner, & Company. A flurry of home loan organizations would use the discount designs to finance construction for the rising middle-class population.

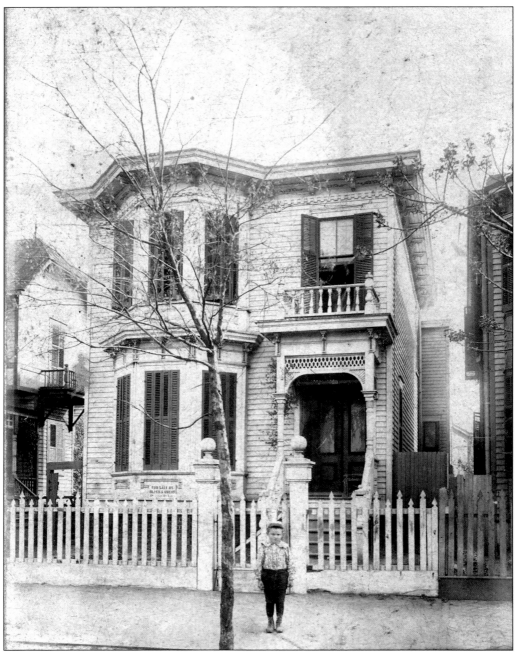

The city was finding real estate in the under developed areas becoming scarce. The *Savannah Morning News* reported in 1888, " there are fewer houses to rent than have ever been . . . there are a dozen or more applicants for every desirable place." This would create a boom for the construction industry. "Contractors are heels over head in work and bustling to complete what they now have on hand so that they may be ready to meet the demands that may be on them early next season." This photo of 405 East Duffy Street (*c.* 1899) shows a typical pattern book house for sale. (GHS Cordray-Foltz #1360.)

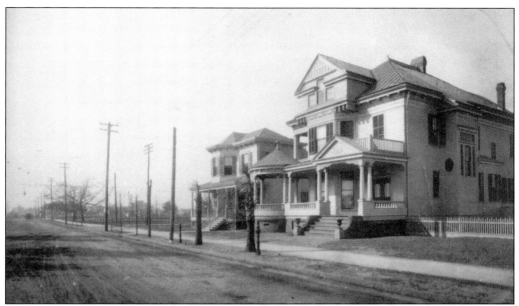

Pattern-book and "carpenter-made" houses transformed the southern section of the city into the quintessential suburban neighborhood. The "flood of frame houses" described by contemporaries of the day came to the Victorian District during the ending decades of the 19th century. These scenes from Bull (above)and Taylor (below) Streets in 1902 show the barren but romantic quality of the suburbs. (from *Artwork of Savannah and Augusta*, 1902.)

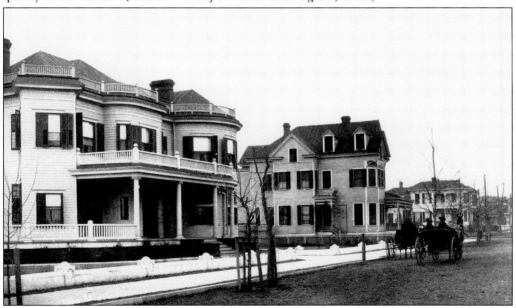

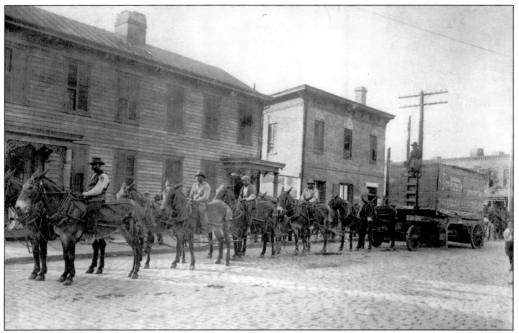

Electricity would come to Savannah in 1882 but would not have widespread use until the turn of the century. This image shows a mule train, *c.* 1910, moving 30,000 pounds of equipment made by General Electric for the Savannah Lighting Company. (GHS #1361PH.)

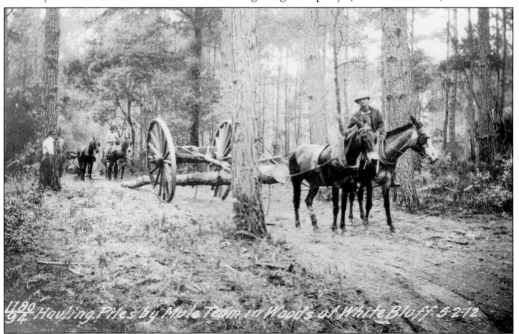

Even with the advantages of modern equipment, most of the forest clearing for Savannah's future development would remain much like it had been for centuries. This image, of men hauling pines at White Bluff, was taken in 1912. (GHS SEPCO #1381.)

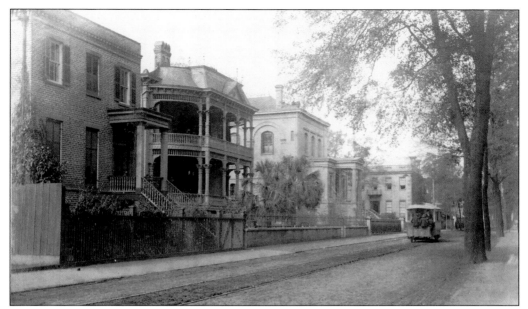

The introduction of streetcars in 1869 would be the catalyst for new suburban developments to the south of the Park Extension. The desirability of lots that bordered Forsyth Place resulted in many elegant constructions. Alfred Snedeker built 503 Whitaker (second from left) in 1883 for Guerrard Heywood. The double piazza is supported by 16 Corinthian iron columns that were cast in Baltimore at a cost of $10,000. (GHS #1276.)

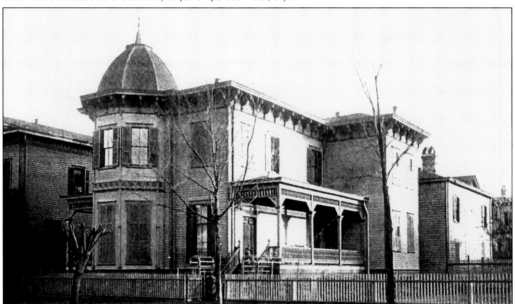

Banker C.H. Dorsett hired professed "church architect" John J. Nevitt to supervise the construction of his house at 215 West Gwinnett Street in 1885. Nevitt designed "Episcopal churches at Washington, Athens and Mt. Airy," before his arrival in Savannah in 1879. In addition to other residences in Savannah, he is credited with the "execution of the ceiling in Christ Episcopal Church." (Courtesy of GHS.)

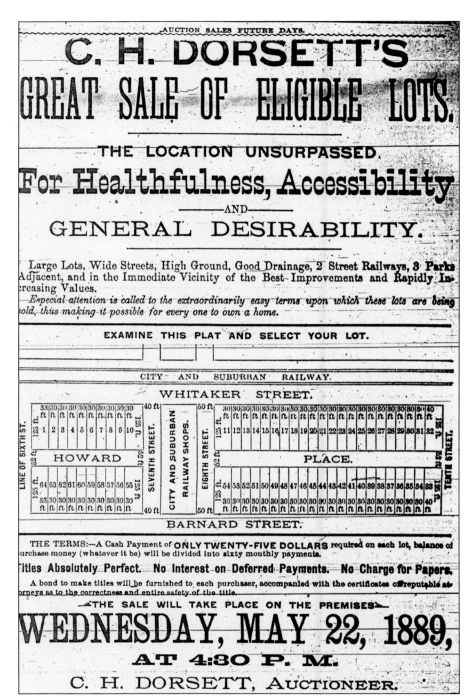

This auction advertisement from the *Savannah Morning News* points to the sale of lots "in the Immediate Vicinity of the Best Improvements and Rapidly Increasing Values." C.H. Dorsett believed in the possibility "for everyone to own a home" and invested heavily in this growing market, but it was no coincidence he also helped develop the streetcar lines that gave these lots their value.

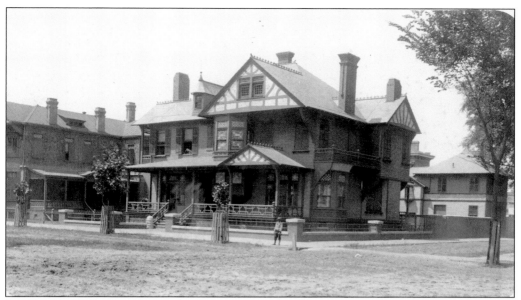

In 1888, J.P. Williams contracted architects Fay and Eichberg to construct 118 West Hall Street, seen in this photo *c.* 1890 (top). In the spring of 1887, the *Savannah Morning News* published Shoppel design #328 (bottom). While not an exact replica of #328, the house, as constructed, "borrows heavily" from Shoppel. (GHS Saussy Family Papers #1276.)

THE EPISCOPAL ORPHANS' HOME.

Designed by J.J. Nevitt in 1886, the Episcopal Orphans Home used an ashlar-faced Peirce stone for the foundation and a brown-tinted stone for window sills and keystones.

Artificial stone was made in Savannah as early as the 1860s, with the formation of the Ransome Stone Manufacturing Company of Georgia. The Peirce Patent Stone and Building Company incorporated in the 1880s, claiming that their stone was the "building material of the future." The predecessor to modern cinder block, the hollow Peirce stone would be used to construct entire houses in Savannah, many having a truly unique architectural character.

THE PEIRCE PATENT

Stone and Building Company

—OF—

SAVANNAH, - GEORGIA.

INCORPORATED.

CAPITAL STOCK - $100,000.

This company deals in a superior quality of Artificial Stone for all building purposes. Buildings, Pavements, Curbing, Bridges, Railroad Culverts, Sewers, Chimneys and Ornamental Tops; Stone Trimmings for Brick Buildings, Sidewalks of all kinds, Cemetery Lots, Garden Walks, Flower Vases, Corridors and Office Floors, Well Curbing, Fire-proof Vaults for Banks and Private Residences, Fountain Bases—in fact, this composite Stone may be applied to any of the uses made of Brick or Stone, and is protected by letters patent. Our Stone is fire-proof and in case of fire the walls will not crack like Brick, Natural Stone or Marble, of which we can give sufficient proof. This Building Stone has been recommended by the Florida Medical and Surgical Journal, which says: "This Stone will be the building material of the future, for aside from its beauty it fulfills all the requisites of sanitation and economy."

Our Blocks have the air space in the Block for circulation of air.

County Right to Manufacture James S. Peirce's

Patent Artificial Stone

in the State of Georgia. For sale at the Company's office.

The invention has for its object the production of an Artificial Stone and Patent Block suitable for all Building and Paving purposes, possessing strength and hardness, and free from efflorescence when exposed to the air; and it consists in the combination of ingredients particularly described in the letters of patent. This Stone is formed into Blocks in any suitable molds and of any desirable color or shape, and can be made at any place where good, clean, silicious sand or broken rock is to be had.

See the Blocks being put in the walls of the new Episcopal Orphan Home now being erected in this city, Jefferson and Liberty streets.

We warn all parties to not make, buy or use articles protected by patent and owned by us.

Call at the Factory, foot of William street, or at the Company's Office, 116½ Bryan street, and leave your order for Stone, etc.

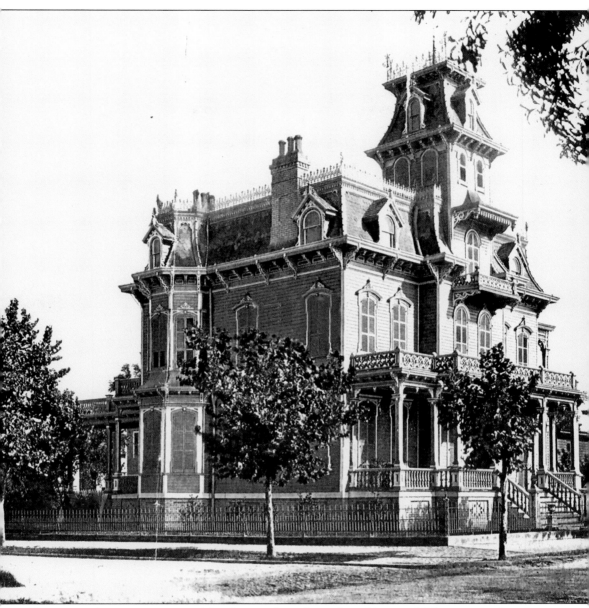

Ornamentation was encouraged by the number of wood working establishments in the city of Savannah, resulting in the transformation of frame houses into displays of opulence. This Second Empire–design home was the residence of R.D. Lester near Forsyth Park and is shown c. 1890. (Courtesy of GHS.)

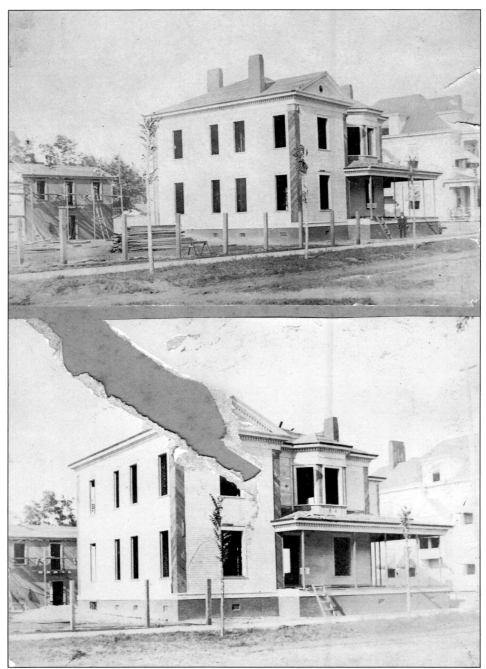

The Billington-Weed house on 39th Street, seen here while under construction in 1899, is representative of the mass of Savannah's wood buildings. On a foundation of brick, the balloon-framed structure is diagonally shethed for rigidity and finished with small modern clapboards. Typical of a pattern-book, carpenter-built house, the structure uses a classical dental molding under eaves instead of the earlier technique of putting brackets. Carved wooden pilasters (not yet in place) would finish the design. (GHS Billington-Weed Scrapbook #1573.)

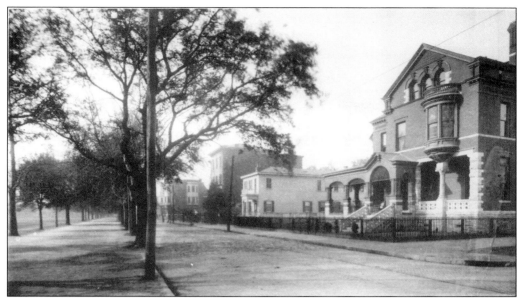

These images from 1902 show both sides of the Park Extension. A.S. Eichberg used a delicate balance of stone, brick, and terra cotta to build the home at 803 Whitaker Street (top right) for J.S. Wood in 1891 at a cost of $20,000. The *Savannah Morning News* in 1893 estimated "nearly 50 new residences of Moorish and Gothic architecture." These houses on Drayton Street (below) show design and massing that were popular before the turn of the 20th century. The now beautiful oak trees can be seen in their infancy. (From *Artwork of Savannah and Augusta*, 1902.)

The *Savannah Morning News* reported in September 1888, "the suburbs are building up and people are moving out from the heart of the city to where they can get more room," and continued to observe, "the suburbs where five years ago there was hardly a single house, are dotted all over with comfortable homes." These are scenes from East Gwinnett Street, *c.* 1902. (From *Artwork of Savannah and Augusta,* 1902.)

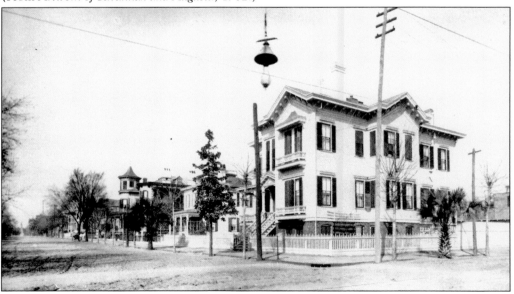

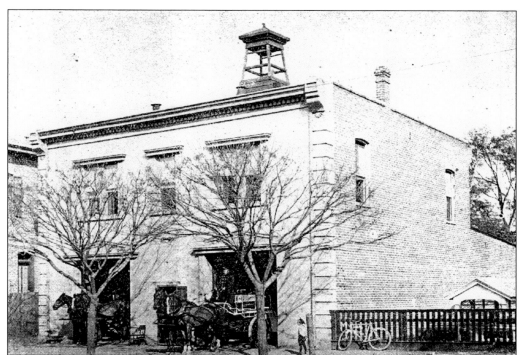

Citizens of the newly developed areas demanded installation of fire protection and services to prevent disaster. The city government understood the danger created by the multitudes of wood buildings built outside the Fire District and responded with the construction of Barnard Street Fire Stations #4 and #6. (From *History of the City Government*, 1904.)

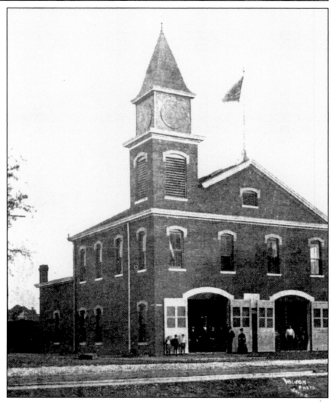

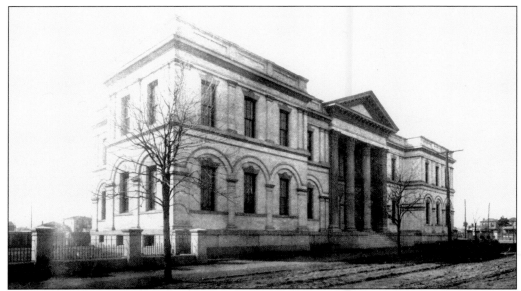

The population of Savannah would triple in the ending decades of the 19th century, and young families would require new schools and educational facilities. Designer of the building at the Atlanta Cotton Exposition, architect Gottfried Norrman planned the school at 412 East Anderson Street (lower) in 1896. The Thirty-eighth Street School is seen above. (From *Artwork of Savannah and Augusta*, 1902.)

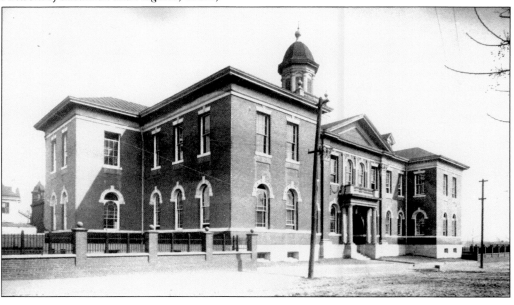

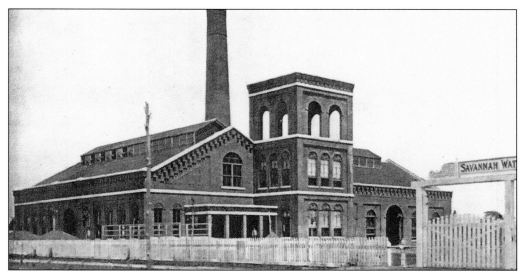

One of the greatest challenges for the growth of the American city at the turn of the 20th century was to supply populations with a clean and dependable water supply. The 31-acre lot for the new water works at the west end of Gwinnett Street was purchased for $17,050 in 1891. Mayor McDonough and the city council solicited the expertise of civil engineer Thomas T. Johnson of Chicago to supervise the plans and specifications of the wells, machinery, and housing. Local builder W.F. Chaplin is credited with construction of the masonry building. At a cost one-half million dollars, the works could supply the city with ten million gallons a day of "artesian water of excellent quality. . . clear and sparkling". (from *Fruits of Industry*, 1895.)

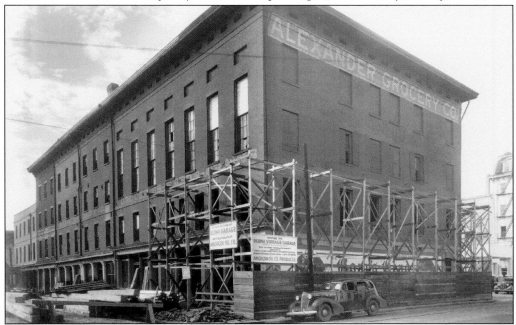

Rehabilitation and preservation of historic buildings in Savannah did not become significant to the city until the tragic loss of many architectural gems. This scene shows the Alexander Grocery under renovation *c.* 1940. (GHS Cordray-Foltz #1360)

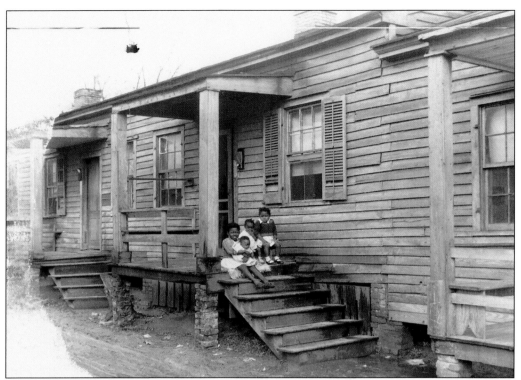

Simple frame cottages and row houses were built near the rail yards on the east and west sides of the city to house the laboring classes of all industries. Often containing multiple families, the one- and two-room houses shown in these photos were used to exposed the abject poverty in the South during the 1930s. (Courtesy of GHS.)

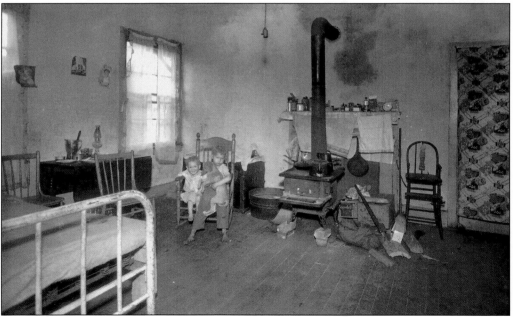

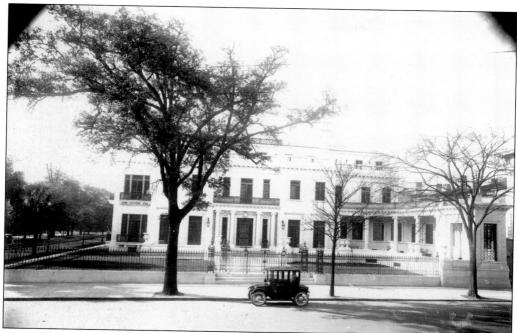

In 1919, architect Henry Wallin recruited artisans from Europe to complete the George F. Armstrong mansion on Bull Street at the foot of Forsyth Place. Swedish-born Wallin originally came to Savannah to help supervise work on Liberty Bank. His love of the ocean and the Southern climate would keep him in Savannah, where he would go on to design the Cortez Cigar Factory, YMCA, Old City Auditorium, DeRenne Apartments, and other notable structures. (GHS Edward Girard VM #1374 and Cordray-Foltz #1360.)

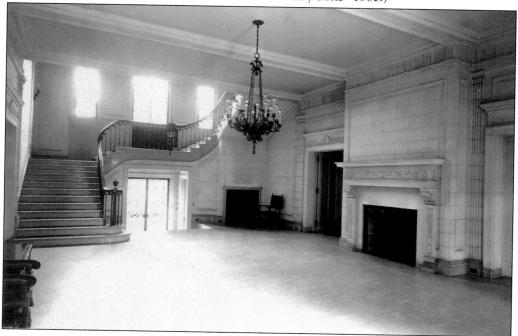

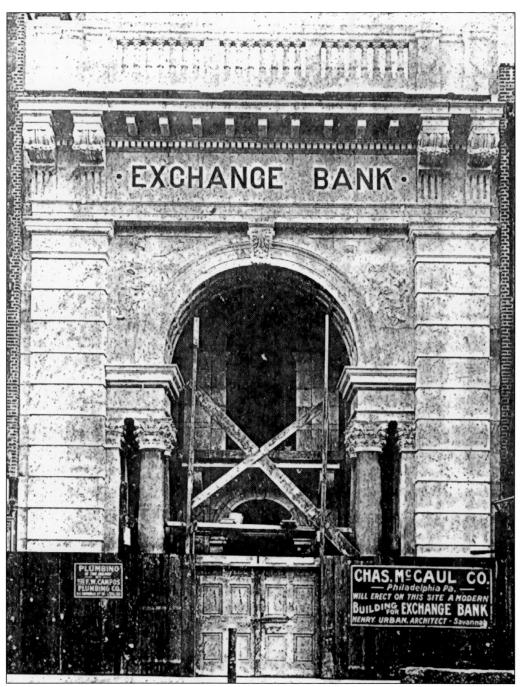

Builders and architects embraced new technology that promised to reduce construction labor, time, and cost. The density of urban areas that led to suburban expansion would also influence Savannah's future building decisions. In this scene from 1912, the Exchange Bank on Broughton Street is slated for demolition to be replaced by a "modern" building by architect Henry Urban.

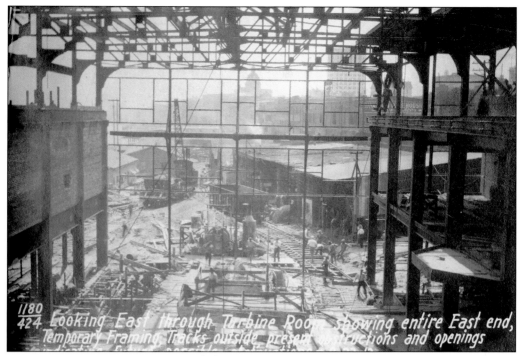

Mayor Herman Meyers recommended in 1895, "Lights are essential to the comfort of the masses and therefore the cost to the public should be brought down to the lowest figures." Construction of the Riverside Powerhouse in 1912 solidified the new role of electricity in the lives of the people of Savannah. Note the outline of the City Hall dome and the new Savannah Bank & Trust building in the distance. (GHS SEPCO #1381.)

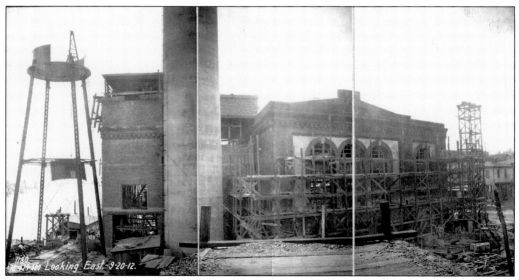

This image chronicles the Powerhouse near completion in 1912. (GHS SEPCO #1381.)

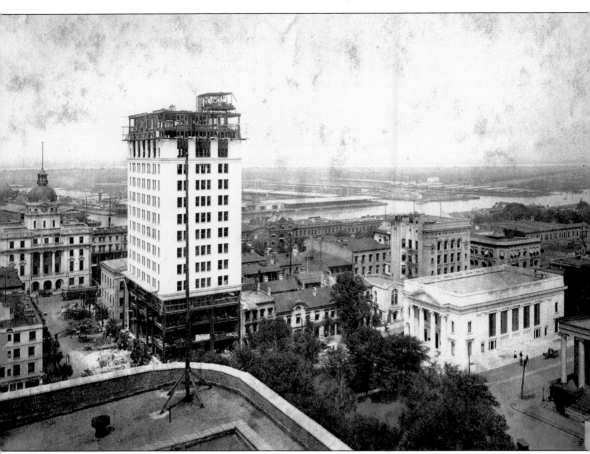

The 20th century brought changes to the physical and dimensional characteristics of Savannah's built environment. The iron and steel that had shaped wood and stone for the 19th century would now become the preeminent material for the construction of the modern world. Ascending the heavens, a new architecture of the "curtain wall" would inspire a revolution in structure, function, and balance. In this 1912 view, the novel construction of the Mowbray and Uffinger–designed Savannah Bank and Trust Company building is juxtaposed between the 1852 U.S. Customs House to the north and the 1838 Christ Episcopal Church to the southeast. The building of Savannah had reached the modern age. (GHS SEPCO #1381.)

Index

page 9—CF#1360PH 29.15.1

page 10—VM#2126-SB2

page 11—VM#1375-106

page 12—#1361PH-29.19.5685

page 15—#1361PH- 20.8.4056/20.8.4058

page 16—Girard #1374-2.21.21/ #1361PH-20.10.4076

page17—CF#1360-28.19.2 / CF#1360-28.13.9

page 18—CF#1360-28.6.11

page 19—CF#1360-20.2. / 20.2.5

page 20—#846F19

page 21—Scudder #719

page 22—CF#1360-8.23.2 / 8.24.9

page 23—Carpenter's Day Book, MS#932-p39

page 24—#1361SG-B2

page 25—Armstrong VM#25

page 26—Waring Collection #1018

page 29—#1361SG-B2

page 32—#1361SG-B2

page 33—F294.S2S2335

page 34—F294.S2I53

page 36—#1361PH 22.28.4470 / 22.29.4476

page 37—CF#1360-20.2.6

page 39—#882-50

page 40—CF#1360-8.23.9

page 41—Saussy #1276-6.47

page 51—SEPCO #1381

page 52—F294.S2I53

page 53—Scudder #719

page 55—Scudder #719

page 56—J.N. Wilson 1375-211.473

page57—#1361PH-20.7.4053

page 58—CF#1360-20.4b.1 / 20.4b.6

page 61—Sawyer #713-B2

page 62—Scudder #719

page 71—CF#1360-16.22.4.7 / 16.22.8.11

page72—CF#1360-20.5.10 / 20.5.3

page 73—CF#1360-20.17.2

page 74—CF#1360- 20.21.1

page 75—Waring Maps #1018

page 77—AD #1361MP-4.6

page 78—CF#1360-7.8.2 / 7.8.3

page 83—MS#686 Vol. 1

page 86—Silva VM#2126-SB1

page 87—CF#1360-6.18.2

page 88—CF#1360-6.21.5

page 89—SHRA #994-4.20 / #1361PR-2.16

page 90—#1378-6.18.2

page 91—#1378-6.21.5

page 92—Hartridge #1349-52.826

page 93—Saussy #1276- 6.48

page 94—Scudder #719-11

page 95—MS#134-3-E-13

page 96—AD #1361MP

page 98—AD #1361MP

page 99—#1361PH-29.5.5558 / 29.5.5902 page 103—
SEPCO #1381

page 104—Wright #2242-S1.2.3

page 105—Anderson #846-504a

page 106—#1500EN-90

page 108—CF#1360-11.14.7

page 110—#1361PH-28.14.5420 / SEPCO #1381

page 111—Saussy #1276-6.48

page 113—Saussy #1276-6.48

page 116—Billington-Weed #1573 SB

page 121—Cordray-Foltz #1360-B13.1.1/ 13.1.4

page 122—CF#1360-8.5.8 / 8.5.3

page 123—Girard VM#1374-1.18.1 / CF#1360-3.23.6a

page125—SEPCO #1381A3

page 126—SEPCP #1381A1

drawings on 54 (lower), 57 (lower), 60 (lower), 66 (lower)—are from *Bird's Eye View of Savannah* by Augustus Koch, 1891. Published by the *Savannah Morning News*. Reproduction by the Georgia Historical Society 1985.

Private Collections

Courtesy Library of the Honorable Mr. and Mrs. Herman Coolidge Sr.

Charles Hart, *Art Work of Savannah*. Chicago: W.H. Parish Publishing Co., 1893.

Charles C. Jones Jr., *History of Savannah*. D. Mason and Co. Syracuse, NY. 1895.

Fruits of Industry: Points and Pictures along the Central of Georgia Railroad. Central of Georgia Railroad System with text by Pleasant A. Stovall and pictures by O. Pierre Havens, 1895.

Charles Edgeworth Jones, *ArtWork of Savannah and Augusta*. Chicago: Photogravure Illustration Co., 1902.

Thomas Gamble, *History of the City Government of Savannah, 1790–1901.* Mayor's Office of the City of Savannah, 1904.